THE MA

Arthur Wing Pinero
THE MAGISTRATE

with text revisions by Stephen Beresford

OBERON BOOKS
LONDON

WWW.OBERONBOOKS.COM

This edition first published in 2012 by Oberon Books Ltd
521 Caledonian Road, London N7 9RH
Tel: +44 (0) 20 7607 3637 / Fax: +44 (0) 20 7607 3629
e-mail: info@oberonbooks.com
www.oberonbooks.com

This typesetting copyright © Oberon Books Ltd, 2012
Revisions copyright © Stephen Beresford 2012

A catalogue record for this book is available from the British Library.

PB ISBN: 978-1-84943-457-7
E ISBN: 978-1-84943-729-5

Cover illustration © Gerald Scarfe, taken from the National
Theatre production poster for *The Magistrate*, design by Charlotte
Wilkinson.

Printed, bound and converted
by CPI Group (UK) Ltd, Croydon, CR0 4YY.

Visit www.oberonbooks.com to read more about all our books
and to buy them. You will also find features, author interviews and
news of any author events, and you can sign up for e-newsletters
so that you're always first to hear about our new releases.

National Theatre

The National Theatre, where this play was staged in November 2012, is central to the creative life of the UK. In its three theatres on the South Bank in London it presents an eclectic mix of new plays and classics from the world repertoire, with seven or eight productions in repertory at any one time. And through an extensive programme of amplifying activities – Platform performances, backstage tours, foyer music, publications, exhibitions and outdoor events – it recognises that theatre doesn't begin and end with the rise and fall of the curtain. The National endeavours to maintain and re-energise the great traditions of the British stage and to expand the horizons of audiences and artists alike. It aspires to reflect in its repertoire the diversity of the nation's culture. It takes a particular responsibility for the creation of new work – offering at the NT Studio a space for research and development for the NT's stages and the theatre as a whole. Through its Learning programme, it invites people of all ages to discover the NT's repertoire, the skills and excitement of theatre-making, and the building itself. As the national theatre, it aims to foster the health of the wider British theatre through policies of collaboration and touring. These activities demonstrate the considerable public benefit provided by the NT, both locally and nationally. Between 20 and 26 new productions are staged each year in one of the NT's three theatres, the Olivier, the Lyttelton and the Cottesloe. In 2011-12, the National's total reach was 2.3 million people worldwide, through attendances on the South Bank, in the West End, on tour and through National Theatre Live, the digital broadcast of live performances to cinema screens all over the world.

Information: +44(0) 20 7452 3400
Box Office: +44(0) 20 7452 3000
National Theatre, South Bank, London SE1 9PX
www.nationaltheatre.org.uk

Registered Charity No: 224223

This production of *The Magistrate* was first performed at the National Theatre, Olivier Theatre, London, 21 November 2012 with the following cast in order of appearance:

Beatie Tomlinson	SARAH OVENS
Cis Farringdon	JOSHUA MCGUIRE
Wyke	ALEXANDER COBB
Popham	BEVERLY RUDD
Agatha Posket	NANCY CARROLL
Mr. Posket	JOHN LITHGOW
Mr. Bullamy	NICHOLAS BLANE
Charlotte	CHRISTINA COLE
Isidore	CHRISTOPHER LOGAN
Achille Blond	DON GALLAGHER
Colonel Lukyn	PATRICK BARLOW
Captain Horace Vale	NICHOLAS BURNS
Inspector Messiter	PETER POLYCARPOU
Constable Harris	JOSHUA LACEY
Sergeant Lugg	SEAN MCKENZIE
Mr. Wormington	ROGER SLOMAN
Dandies	TAMSIN CARROLL
	RICHARD FREEMAN
	AMY GRIFFITHS
	NICHOLAS LUMLEY
	JOSHUA MANNING
	JEZ UNWIN
Director	TIMOTHY SHEADER
Designer	KATRINA LINDSAY
Lighting Designer	JAMES FARNCOMBE
Lyrics	RICHARD STILGOE
Music	RICHARD SISSON
Movement Director	LIAM STEEL
Sound Designer	PAUL ARDITTI
Vocal Arranger	DAVID SHRUBSOLE

Characters

MR. POSKET
magistrate of the Mulberry Street Police Court

MR. BULLAMY
magistrate of the Mulberry Street Police Court

COLONEL LUKYN
from Bengal, retired

CAPTAIN HORACE VALE
Shropshire Fusiliers

CIS FARRINGDON
Mrs. Posket's son by her first marriage

ACHILLE BLOND
proprietor of the Hôtel des Princes

ISIDORE
a waiter

MR. WORMINGTON
chief clerk at Mulberry Street

INSPECTOR MESSITER
Metropolitan Police

SERGEANT LUGG
Metropolitan Police

CONSTABLE HARRIS
Metropolitan Police

WYKE
servant at Mr. Posket's

AGATHA POSKET
late Farringdon, *née* Verrinder

CHARLOTTE
her sister

BEATIE TOMLINSON
a young lady reduced to teaching music

POPHAM

Act One

A well-furnished drawing-room in the house of MR. POSKET in Bloomsbury.

BEATIE TOMLINSON, a pretty, simply dressed little girl of about sixteen, is playing the piano, as CIS FARRINGDON, a manly youth wearing an Eton jacket, enters the room.

CIS: Beatie!

BEATIE: Cis dear! Dinner isn't over, surely?

CIS: Not quite. I had one of my convenient headaches and cleared out. *(Taking an apple and some cobnuts from his pocket and giving them to BEATIE.)* These are for you, dear, with my love. I sneaked 'em off the sideboard as I came out.

BEATIE: Oh, I mustn't take them!

CIS: Yes, you may – it's my share of dessert. Besides, it's a horrid shame you don't grub with us.

BEATIE: What, a poor little music mistress!

CIS: Yes. They're only going to give you four guineas a quarter. Fancy getting a girl like you for four guineas a quarter – why, an eighth of you is worth more than that! Now peg away at your apple. *(Produces a cigarette.)*

BEATIE: There's company at dinner, isn't there? *(Munching her apple.)*

CIS: Well, hardly. Aunt Charlotte hasn't arrived yet, so there's only old Bullamy.

BEATIE: Isn't old Bullamy anybody?

CIS: Old Bullamy – well, he's only like the Guv'nor, a police magistrate at the Mulberry Street Police Court.

BEATIE: Oh, does each police court have two magistrates?

CIS: *(Proudly.)* All the best have two.

BEATIE: Don't they quarrel over getting the interesting cases? I should.

CIS: I don't know how they manage – perhaps they toss up who's to hear the big sensations.

He sits on the floor, comfortably reclining against BEATIE, and puffing his cigarette.

BEATIE: Oh, I say, Cis, won't your mamma be angry when she finds I haven't gone home?

CIS: Oh, put it on to your pupil. *(Kissing her.)* Say, I'm very backward.

BEATIE: I think you are extremely forward – in some ways. I do wish I could get you to concentrate your attention on your music lessons. But I wouldn't get you into a scrape.

CIS: No fear of that. Ma is too proud of me.

BEATIE: But there's your step – father.

CIS: The dear old Guv'nor! Why, he's too good – natured to say 'Bo!' to a goose. You know, Beatie, I was at a school at Brighton when ma got married – when she got married the second time, I mean – and the Guv'nor and I didn't make each other's acquaintance till after the honeymoon.

BEATIE: Oh, fancy your step – father blindly accepting such a responsibility! *(Gives him a cobnut to crack for her.)*

CIS: Yes, wasn't the Guv'nor soft! I might have been a very indifferent sort of young fellow for all he knew.

Having cracked the nut with his teeth, he returns it to her.

BEATIE: Thank you, dear.

CIS: Well, when I heard the new dad was a police magistrate, I *was* scared. Said I to myself, 'If I don't mind my Ps and Qs, the Guv'nor – from force of habit – will fine me all my pocketmoney.' But it's quite the reverse – he's the mildest, meekest – *(The door opens suddenly.)* Look out! Someone coming!

They both jump up, BEATIE scattering the nuts that are in her lap all over the floor. CIS throws his cigarette into the fireplace and sits at the piano, playing a simple exercise very badly. BEATIE stands behind him, counting.

BEATIE: One – and two – and one – and two.

WYKE, the butler, appears at the door, and mysteriously closes it after him.

WYKE: *(In a whisper.)* Ssss! Master Cis! Master Cis!

CIS: Hallo – what is it, Wyke?

WYKE: *(Producing a decanter from under his coat.)* The port wine what you asked for, sir. I couldn't get it away before – the old gentlemen do hug port wine so.

CIS: Got a glass?

WYKE: Yes, sir. *(Producing wine – glass from his pocket, and pouring out wine.)* What ain't missed ain't mourned eh Master Cis?

WYKE: *(To himself, watching them.)* What a young gentleman it is, and only fourteen! Fourteen – he behaves like forty! *(CIS chokes as he IS drinking the wine; BEATIE pats him on the back.)* Why, even Cook has made a 'ash of everything since he's been in the house, and as for Popham – ! *(Seeing someone approaching.)* Look out, Master Cis!

CIS returns to the piano, BEATIE counting as before. WYKE pretends to arrange the window curtains, concealing the decanter behind him.

BEATIE: One and two – and one and two – and one, etc.

Enter POPHAM, a smart-looking maid-servant.

POPHAM: Wyke, where's the port?

WYKE: *(Vacantly.)* Port?

POPHAM: Port wine. Missus is furious.

WYKE: Port?

POPHAM: *(Pointing to the decanter.)* Why! There! You're carrying it about with you!

WYKE: Why, so I am! Carrying it about with me! Shows what a sharp eye I keep on the Guv'nor's wines. Carrying it about with me! Missus will be amused. *(Goes out.)*

POPHAM: *(Eyeing CIS and BEATIE. To herself.)* There's that boy with *her* again! Minx! Her two hours was up long ago. Why doesn't she go home? Master Cis, I've got a message for you.

CIS: For me, Popham?

POPHAM: Yes, sir. *(Quietly to him.)* The message is from a young lady who up to last Wednesday was all in all to you. Her name is Emma Popham.

CIS: *(Trying to get away.)* Oh, go along, Popham!

POPHAM: *(Holding his sleeve.)* Ah, it wasn't 'Go along, Popham' till that music girl came into the house. I will go along, but – cast your eye over this before you sleep tonight. *(She takes out of her pocket – handkerchief a piece of printed paper which she hands him between her finger and thumb.)* Part of a story in *Bow Bells* called 'Jilted; or, Could Blood Atone?' Wrap it in your handkerchief – it came round the butter.

She goes out; CIS throws the paper into the grate.

CIS: Bother the girl! Beatie, she's jealous of you!

BEATIE: A parlourmaid jealous of *me* – and with a bit of a child of fourteen!

CIS: I may be only fourteen, but I feel like a grown-up man! You're only sixteen – there's not much difference – and if you will only wait for me, I'll soon catch you up and be as much a man as you are a woman. *(Lovingly.)* Will you wait for me, Beatie?

BEATIE: I can't – I'm getting older every minute!

CIS: *(Desperately.)* Oh, I wish I could borrow five or six years from somebody!

BEATIE: Many a person would be glad to lend them. *(Lovingly.)* And oh, I wish you could!

CIS: *(Putting his arm round her.)* You do! Why?

BEATIE: Because I – because – 1

CIS: *(Listening.)* Look out! Here's the mater!

They run to the piano; he resumes playing, and she counting as before.

BEATIE: One and two – and one – and two, etc.

Enter AGATHA POSKET, a handsome, showy woman, of about thirty-six, looking perhaps younger.

AGATHA: Why, Cis child, at your music again?

CIS: Yes, ma, always at it. You'll spoil my taste by forcing it if you're not careful.

AGATHA: We have no right to keep Miss Tomlinson so late.

BEATIE: *(Nervously.)* Oh, thank you, it doesn't matter. I – I am afraid we're not making – very – great – progress.

CIS: *(Winking at BEATIE.)* Well, if I play that again, will you kiss me?

BEATIE: *(Demurely.)* I don't know, I'm sure. *(To AGATHA.)* May I promise that, ma'am?

Sits in the window recess. CIS joining her, puts his arm round her waist.

AGATHA: *(Sharply.)* No, certainly not. *(To herself, watching them.)* If I could only persuade Aeneas to dismiss this *protégée* of his, and to engage a music-master, it would ease my conscience a little. If this girl knew the truth, how indignant she would be! And then there is the injustice to the boy himself, and to my husband's friends who are always petting and fondling and caressing what they call 'a fine little man of fourteen!' Fourteen! Oh, what an idiot I have been to conceal my child's real age! *(Looking at the clock.)* Charlotte is late; I wish she would come. It will be a relief to worry her with my troubles.

POSKET: *(Outside.)* We smoke all over the house, Bullamy, all over the house.

AGATHA: I will speak to Aeneas about this little girl, at any rate.

Enter POSKET, a mild gentleman of about fifty, smoking a cigarette, followed by BULLAMY, a fat, red-faced man with a bronchial cough and general huskiness.

POSKET: Smoke anywhere, Bullamy – smoke anywhere.

BULLAMY: Not with my bronchitis, thank ye.

POSKET: *(Beaming at AGATHA.)* Ah, my darling!

BULLAMY: *(Producing a small box from his waistcoat pocket.)* All I take after dinner is a jujube – sometimes two. *(Offering the box.)* May I tempt Mrs. Posket?

AGATHA: No, thank you. *(Treading on one of the nuts which have been scattered over the room.)* How provoking – who brings nuts into the drawing-room?

POSKET: Miss Tomlinson still here? *(To BEATIE.)* Don't go, don't go. Glad to see Cis so fond of his music. Your sister Charlotte is behind her time, my darling.

AGATHA: Her train is delayed, I suppose.

POSKET: You must stay and see my sister-in-law, Bullamy.

BULLAMY: Pleasure – pleasure!

POSKET: *I* have never met her yet; we will share first impressions. In the interim, will Miss Tomlinson delight us with a little music?

BULLAMY: *(Bustling up to the piano.)* If this young lady is going to sing she might like one of my jujubes.

BEATIE sits at the piano with CIS and BULLAMY on each side of her. POSKET treads on a nut as he walks over to his wife.

POSKET: Dear me – how come nuts into the drawing-room? *(To AGATHA.)* Of what is my darling thinking so

deeply? *(Treads on another nut.)* Another! My pet, there are nuts on the drawing-room carpet!

AGATHA: *(Rousing herself.)* Yes. I want to speak to you, Aeneas.

POSKET: About the nuts?

AGATHA: No – about Miss Tomlinson – your little *protégée.*

POSKET: Ah, nice little thing.

AGATHA: Very. But not old enough to exert any decided influence over the boy's musical future. Why not engage a master?

POSKET: What, for a mere child?

AGATHA: A mere child – oh!

POSKET: A boy of fourteen!

AGATHA: *(To herself.)* Fourteen!

POSKET: A boy of fourteen, not yet out of Czerny's exercises.

AGATHA: *(To herself.)* If we were alone now, I might have the desperation to tell him all!

POSKET: Besides, my darling, you know the interest I take in Miss Tomlinson; she is one of the brightest little spots on my hobby-horse. Like all our servants, like everybody in my employ, she has been brought to my notice through the unhappy medium of the Police Court over which it is my destiny to preside. Our servant, Wyke, a man with a beautiful nature, is the son of a person I committed for trial for marrying three wives. To this day, Wyke is ignorant as to which of those three wives he is the son of! Cook was once a notorious dipsomaniac, and has even now not entirely freed herself from early influences. Popham is the unclaimed charge of a convicted baby-farmer. Even our milkman came before me as a man who had refused to submit specimens to the analytic inspector. And this poor child, what is – she?

AGATHA: Yes, I know.

POSKET: The daughter of a superannuated General, who abstracted four silk umbrellas from the Army and Navy Stores – and on a fine day too! *(BEATIE ceases playing.)*

BULLAMY: Very good – very good!

POSKET: Thank you – thank you!

BULLAMY: *(To POSKET, coughing and laughing and popping a jujube into his mouth.)*

My dear Posket, I really must congratulate you on that boy of yours – your step-son. A most wonderful lad. So confoundedly advanced too.

POSKET: Yes, isn't he? Eh!

BULLAMY: *(Confidentially.)* While the piano was going on just now, he told me one of the most humorous stories I've ever heard. *(Laughing heartily and panting, then taking another jujube.)* Ha, ha! Bless me, I don't know when I have taken so many jujubes!

POSKET: My dear Bullamy, my entire marriage is the greatest possible success. A little romantic too. *(Pointing to AGATHA.)* Beautiful woman!

BULLAMY: Very, very. *(Looking at her through eyeglass.)* I never convicted a more stylish, elegant creature.

POSKET: *(Warmly.)* Thank you, Bullamy – we met abroad, at Spa, when I was on my holiday.

Enter WYKE, with tea-tray, which he hands round.

BULLAMY: I shall go there next year.

POSKET: She lost her first husband about twelve months ago in India. He was an army contractor.

BEATIE: *(To CIS at the piano.)* I must go now – there's no excuse for staying any longer.

CIS: *(To her disconsolately.)* What the deuce shall *I* do?

POSKET: *(Pouring out milk.)* Dear me, this milk seems very poor. When he died, she came to England, placed her boy

at a school in Brighton, and then moved about quietly from place to place, drinking – *(Sips tea.)*

BULLAMY: *(With concern.)* Drinking?

POSKET: The waters – she's a little dyspeptic. *(WYKE goes out.)* We encountered each other at the *Tours des Fontaines* – by accident I trod upon her dress –

BEATIE: Good-night, Cis dear.

CIS: Oh!

POSKET: I apologised. We talked about the weather, we drank out of the same glass, discovered that we both suffered from the same ailment, and the result is complete happiness.

He bends over AGATHA gallantly.

AGATHA: Aeneas!

He kisses her; then CIS kisses BEATIE, loudly. POSKET and BULLAMY both listen puzzled.

POSKET: Echo?

BULLAMY: Suppose so!

He kisses the back of his hand experimentally; BEATIE kisses CIS.

Yes.

POSKET: Curious. *(To BULLAMY.)* Romantic story, isn't it?

BEATIE: Good-night, Mrs. Posket. I shall be here again tomorrow.

AGATHA: I am afraid you are neglecting your other pupils.

BEATIE: *(Confused.)* Oh, they're not so interesting as Cis. *(Correcting herself.)* Master Farringdon. Good-night.

AGATHA: Good-night, dear. *(BEATIE goes out quietly.)*

POSKET: *(To BULLAMY.)* We were married abroad without consulting friends or relations on either side. That's how it is I have never seen my sister-in-law, Miss Verrinder, who is coming from Shropshire to stay with us – she ought to –

Enter WYKE.

WYKE: Miss Verrinder has come, ma'am.

POSKET: Here she is.

AGATHA: Charlotte!

Enter CHARLOTTE, a fine handsome girl, followed by POPHAM with hand luggage.

AGATHA: *(Kissing her.)* My dear Charley.

WYKE goes out.

CHARLOTTE: Aggy darling, aren't I late! There's a fog on the line – you could cut it with a knife. *(Seeing CIS.)* Is that your boy?

AGATHA: Yes.

CHARLOTTE: Good gracious! What is he doing in an Eton jacket at his age?

AGATHA: *(Softly to CHARLOTTE.)* Hush! Don't say a word about my boy's age yet awhile.

CHARLOTTE: Oh!

AGATHA: *(About to introduce POSKET.)* There is my husband.

CHARLOTTE: *(Mistaking BULLAMY for him.)* Oh, how could she! *(To BULLAMY, turning her cheek to him.)* I congratulate you – I suppose you ought to kiss me.

AGATHA: No, no!

POSKET: Welcome to my house, Miss Verrinder.

CHARLOTTE: Oh, I beg your pardon. How do you do?

BULLAMY: *(To himself.)* Mrs. Posket's an interfering woman.

POSKET: *(Pointing to BULLAMY.)* Mr. Bullamy.

BULLAMY, aggrieved, bows stiffly.

AGATHA: Come upstairs, dear; will you have some tea?

CHARLOTTE: No, thank you, pet, but I should like a glass of soda water.

AGATHA: Soda water!

CHARLOTTE: Well, dear, you can put what you like at the bottom of it.

AGATHA and CHARLOTTE go out, POPHAM following.

POPHAM: *(To CIS.)* Give me back my *Bow Bells* when you have read it, you imp. *(Goes out.)*

CIS: By Jove, Guv, isn't Aunt Charlotte a stunner?

POSKET: Seems a charming woman.

BULLAMY: *(To himself.)* Posket's got the wrong one! That comes of marrying without first seeing the lady's relations.

CIS: Come along, Guv – let's have a gamble – Mr. Bullamy will join us. *(Opens the card-table, arranges chairs and candles.)*

BULLAMY: A gamble?

POSKET: Yes – the boy has taught me a new game called 'Fireworks'; his mother isn't aware that we play for money, of course, but we do.

BULLAMY: Ha, ha, ha! Who wins?

POSKET: He does now – but he says I shall win when I know the game better.

BULLAMY: What a boy he is!

POSKET: *(Delighted.)* Isn't he a wonderful lad? And only fourteen, too. I'll tell you something else – perhaps you had better not mention it to his mother.

BULLAMY: No, no, certainly not.

POSKET: He's invested a little money for me.

BULLAMY: What in?

POSKET: Not *in* – *on* – on Sillikin for the Lincolnshire Handicap. Sillikin to win and Butterscotch one, two, three.

BULLAMY: Good Lord!

POSKET: Yes, the dear boy said, 'Guv, it isn't fair you should give me all the tips; I'll give you some' – and he did – he gave me Sillikin and Butterscotch. He'll manage it for you, if you like. 'Plank it down', he calls it.

BULLAMY: *(Chuckling and choking.)* Ha, ha! Ho, ho! *(Taking a jujube.)* This boy will ruin me in jujubes.

CIS: All ready. Look sharp! Guv, lend me a sov to start with?

POSKET: A sov to start with? *(They sit at the table upstage. AGATHA and CHARLOTTE come into the room.)* We didn't think you would return so soon, my darling.

AGATHA: Go on amusing yourselves, I insist; only don't teach my Cis to play cards.

BULLAMY: Ho, ho!

POSKET: *(To BULLAMY.)* Hush! Hush!

AGATHA: *(To CHARLOTTE.)* I'm glad of this – we can tell each other our miseries undisturbed. Will you begin?

CHARLOTTE: Well, at last I am engaged to Captain Horace Vale.

AGATHA: Oh! Charley, I'm so glad!

CHARLOTTE: Yes – so is he – he says. He proposed to me at the Hunt Ball – in the passage – Tuesday week.

AGATHA: What did he say?

CHARLOTTE: He said, 'By Jove, I love you awfully.'

AGATHA: Well – and what did you say?

CHARLOTTE: Oh, I said, 'Well, if you're going to be as eloquent as all that, by Jove, I can't stand out.' So we settled it in the passage. He bars flirting till after we're married. That's my misery. What's yours, Aggy?

AGATHA: Something awful!

CHARLOTTE: Cheer up, Aggy! What is it?

AGATHA: Well, Charley, you know I lost my poor dear first husband at a very delicate age.

CHARLOTTE: Well, you were five-and-thirty, dear.

AGATHA: Yes, that's what I mean. Five-and-thirty is a very delicate age to find yourself single. You're neither one thing nor the other. You're not exactly a filly, and you don't care to pull a hansom. However, I soon met Mr. Posket at Spa – bless him!

CHARLOTTE: And you nominated yourself for the Matrimonial Stakes.

AGATHA: Yes, Charley, and in less than a month I went triumphantly over the course. But, Charley dear, I didn't carry the fair weight for age – and that's my trouble.

CHARLOTTE: Oh, dear!

AGATHA: Undervaluing Aeneas' love, in a moment of, I hope, not unjustifiable vanity, I took five years from my total, which made me thirty-one on my wedding morning.

CHARLOTTE: Well, dear, many a misguided woman has done that before you.

AGATHA: Yes, Charley, but don't you see the consequences? It has thrown everything out. As I am now thirty-one, instead of thirty-six as I ought to be, it stands to reason that I couldn't have been married twenty years ago, which I was. So I have had to fib in proportion.

CHARLOTTE: I see – making your first marriage occur only fifteen years ago.

AGATHA: Exactly.

CHARLOTTE: Well then, dear, why worry yourself further?

AGATHA: Well, dear, don't you see? If I am only thirty-one now, my boy couldn't have been born nineteen years ago, and if he could, he oughtn't to have been, because on my own showing I wasn't married till four years later. Now you see the result!

CHARLOTTE: Which is, that fine gentleman over there is only fourteen.

CIS: *(From table.)* Fireworks!

AGATHA: Precisely. Isn't it awkward! And his moustache is becoming more and more obvious every day.

CHARLOTTE: What does the boy himself believe?

AGATHA: He believes his mother, of course, as a boy should. As a prudent woman, I always kept him in ignorance of his age – in case of necessity. But it is terribly hard on the poor child, because his aims, instincts, and ambitions are all so horribly in advance of his condition. His food, his books, his amusements are out of keeping with his palate, his brain, and his disposition.

CHARLOTTE: Of course.

AGATHA: And with all this suffering – his wretched mother has the remorseful consciousness of having shortened her offspring's life.

CHARLOTTE: Oh, come, you haven't quite done that.

AGATHA: Yes, I have – because, if he lives to be a hundred, he must be buried at ninety-five.

CHARLOTTE: That's true.

AGATHA: Then there's another aspect. He's a great favourite with all our friends – women friends especially. Even his little music mistress and the girl-servants hug and kiss him because he's such an engaging boy, and I can't stop it. But it's very awful to see these innocent women fondling a young man of nineteen.

CHARLOTTE: The women don't know it.

AGATHA: But they'd like to know it. They ought to know it! The other day I found my poor boy sitting on Lady Jenkins's lap, and in the presence of Sir George. I have no right to compromise Lady Jenkins in that way. And now,

Charley, you see the whirlpool in which I am struggling – if you can throw me a rope, pray do.

CHARLOTTE: What sort of a man is Mr. Posket, Aggy?

AGATHA: The best creature in the world. He's a practical philanthropist.

CHARLOTTE: Um – he's a police magistrate, too, isn't he?

AGATHA: Yes, but he pays out of his own pocket half the fines he inflicts. That's why he has had a reprimand from the Home Office for inflicting such light penalties.

CHARLOTTE: Take my advice – tell him the whole story.

AGATHA: I dare not!

CHARLOTTE: Why?

AGATHA: I should have to take such a back seat for the rest of my married life.

The party at the card-table breaks up.

BULLAMY: *(Grumpily.)* No, thank ye, not another minute. What is the use of talking about revenge, my dear Posket, when I haven't a penny piece left to play with?

POSKET: *(Distressed.)* I'm in the same predicament! Cis will lend us some money, won't you, Cis?

CIS: Rather!

BULLAMY: No, thank ye, that boy is one too many for me. I've never met such a child. Good-night, Mrs. Posket. *(Treads on a nut.)* Confound the nuts!

AGATHA: Going so early?

CIS: I hate a bad loser, don't you, Guv?

AGATHA: Show Mr. Bullamy down stairs, Cis.

BULLAMY: Good-night, Posket. Oh! I haven't a shilling left for my cabman.

CIS: I'll pay the cab.

BULLAMY: No, thank ye! I'll walk. *(Opening jujube box.)* Bah! Not even a jujube left and on a foggy night, too! Ugh! *(Goes out.)*

Enter WYKE, with four letters on salver.

CIS: Any for me?

WYKE: One, sir.

CIS: *(To himself.)* From Achille Blond; lucky the mater didn't see it.

Goes out. WYKE hands letters to AGATHA, who takes two, then to POSKET, who takes one.

AGATHA: This is for you, Charley – already. *(WYKE goes out.)*

CHARLOTTE: Spare my blushes, dear – it's from Horace, Captain Vale. The dear wretch knew I was coming to you. Heigho! Will you excuse me?

POSKET: Certainly.

AGATHA: Excuse me, please?

CHARLOTTE: Certainly, my dear.

POSKET: Certainly, my darling. Excuse me, won't you?

CHARLOTTE: Oh, certainly.

AGATHA: Certainly, Aeneas.

Simultaneously they all open their letters, and lean back and read.

Lady Jenkins is not feeling very well.

CHARLOTTE: *(Angrily.)* If Captain Horace Vale stood before me at this moment, I'd slap his face!

AGATHA: Charlotte!

CHARLOTTE: *(Reading.)* 'Dear Miss Verrinder – Your desperate flirtation with Major Bristow at the Meet on Tuesday last, three days after our engagement, has just come to my knowledge. Your letters and gifts, including the gold-headed hair-pin given me at the Hunt Ball, shall be

returned tomorrow. By Jove, all is over! Horace Vale.' Oh, dear!

AGATHA: Oh, Charley, I'm so sorry! However, you can deny it.

CHARLOTTE: *(Weeping.)* That's the worst of it; I can't.

POSKET: *(To AGATHA.)* My darling, you will be delighted. A note from Colonel Lukyn.

AGATHA: Lukyn – Lukyn? I seem to know the name.

POSKET: An old schoolfellow of mine who went to India many years ago. He has just come home. I met him at the club last night and asked him to name an evening to dine with us. He accepts for to-morrow.

AGATHA: Lukyn, Lukyn?

POSKET: Listen. *(Reading.)* 'It will be especially delightful to me, as I believe I am an old friend of your wife and of her first husband. You may recall me to her recollection by reminding her that I am the Captain Lukyn who stood sponsor to her boy when he was christened at Baroda.'

AGATHA: *(Giving a loud scream.)* Oh!

POSKET: My dear!

AGATHA: I – I've twisted my foot.

POSKET: How *do* nuts come into the drawing-room?

Picks up nut and puts it on the piano.

CHARLOTTE: *(Quietly to AGATHA.)* Aggy?

AGATHA: *(To CHARLOTTE.)* The boy's godfather.

CHARLOTTE: When was the child christened?

AGATHA: A month after he was born. They always are.

POSKET: *(Reading the letter again.)* This is *very* pleasant.

AGATHA: Let – let me see the letter, I – I may recognize the handwriting.

POSKET: *(Handing her the letter.)* Certainly, my pet. *(To himself.)* Awakened memories of Number One. *(Sighing.)* That's the worst of marrying a widow; somebody is always proving her previous convictions.

AGATHA: *(To CHARLOTTE.)* 'No. 19a, Cork Street.' Charley, put on your things and come with me.

CHARLOTTE: Agatha, you're mad!

AGATHA: I'm going to shut this man's mouth before he comes into this house to-morrow.

AGATHA: Aeneas!

POSKET: My dear.

AGATHA: Lady Jenkins – Adelaide – is very ill; she can't put her foot to the ground with neuralgia.

Taking the letter from her pocket, and giving it to him.

POSKET: Bless me!

AGATHA: We have known each other for six long years.

POSKET: Only six weeks, my love.

AGATHA: Weeks *are* years in close friendship. My place is by her side.

POSKET: *(Reading the letter.)* 'Slightly indisposed, caught trifling cold at the Dog Show. Where do you buy your handkerchiefs?' There's nothing about neuralgia or putting her foot to the ground here.

AGATHA and CHARLOTTE go out.

Enter CIS hurriedly.

CIS: What's the matter, Guv?

POSKET: Your mother and Miss Verrinder are going out.

CIS: Out of their minds? It's a horrid night.

POSKET: Yes, but Lady Jenkins is ill.

CIS: Oh! Is ma mentioned in the will?

POSKET: *(Shaded.)* Good gracious, what a boy! No, Cis, your mother is merely going to sit by Lady Jenkins's bedside, to hold her hand, and to tell her where one goes to – to buy pocket-handkerchiefs.

CIS: *(Struck with an idea.)* By Jove! The mater can't be home again till half-past twelve or one o'clock.

POSKET: Much later if Lady Jenkins's condition is alarming.

CIS: Hurray! *(He takes the watch out of POSKET's pocket.)* Just half-past ten. Greenwich mean, eh Guv?

He puts the watch to his ear, pulling POSKET towards him by the chain.

POSKET: What an extraordinary lad!

CIS: *(Rewinding watch.)* Thanks. They have to get from here to Campden Hill and back again. I'll tell Wyke to get them the worst horse on the rank.

POSKET: My dear child!

CIS: Three-quarters of an hour's journey from here at least. Twice three-quarters, one hour and a half. An hour with Lady Jenkins – when women get together, you know, Guv, they do talk – that's two hours and a half. Good. Guv, will you come with me?

POSKET: *(Horrified.)* Go with you! Where?

CIS: Hôtel des Princes, Meek Street. A sharp hansom does it in ten minutes.

POSKET: Meek Street, Hôtel des Princes! Child, do you know what you're talking about?

CIS: Rather. Look here, Guv, honour bright – no blab if I show you a letter.

POSKET: I won't promise anything.

CIS: You won't! Do you know, Guv, you are doing a very unwise thing to check the confidence of a lad like me?

POSKET: Cis, my boy!

CIS: Can you calculate the inestimable benefit it is to a youngster to have someone always at his elbow, someone older, wiser, and better off than himself?

POSKET: Of course, Cis, of course, I *want* you to make a companion of me.

CIS: Then how the deuce can I do that if you won't come with me to Meek Street?

POSKET: Yes, but deceiving your mother!

CIS: *Deceiving* the mater would be to tell her a crammer – a thing, I hope, we're both of us much above.

POSKET: Good boy, good boy.

CIS: *Concealing* the fact that we're going to have a bit of supper at the Hôtel des Princes is doing my mother a great kindness, because it would upset her considerably to know of the circumstances. You've been wrong, Guv, but we won't say anything more about that. Read the letter. *(Gives POSKET the letter.)*

POSKET: *(Reading in a dazed sort if a way.)* 'Hôtel des Princes, Meek Street, W. Dear Sir – Unless you drop in and settle your arrears, I really cannot keep your room for you any longer. Yours obediently, Achille Blond. Cecil Farringdon, Esq.' Good heavens! You have a room at the Hôtel des Princes!

CIS: A room! It's little better than a coop.

POSKET: You don't occupy it?

CIS: But my friends do. When I was at Brighton I was in with the best set – hope I always shall be. Guv, I didn't want them to make free with your house.

POSKET: *(Weakly.)* Oh, didn't you?

CIS: So I took a room at the Hôtel des Princes – when I want to put a man up he goes there. You see, Guv, it's *you* I've been considering more than myself.

POSKET: *(Beside himself.)* But you are a mere child!

28

CIS: A fellow is just as old as he feels. I feel no end of a man. Hush, they're coming down! I'm off to tell Wyke about the rickety four-wheeler.

POSKET: Cis, Cis! Your mother will discover I have been out.

CIS: Oh, I forgot, you're married, aren't you?

POSKET: Married!

CIS: Say you are going to the club.

POSKET: But that's not the truth, sir!

CIS: Yes it is. We'll pop in at the club on our way, and you can give me a bitters. *(Goes out.)*

POSKET: Good gracious, what a boy! Hôtel des Princes, Meek Street! What shall I do? Tell his mother? Why, it would turn her hair grey. If I could only get a quiet word with this Mr. Achille Blond, I could put a stop to everything. That is my best course, not to lose a moment in rescuing the child from his boyish indiscretion. Yes, I must go with Cis to Meek Street.

Enter AGATHA and CHARLOTTE, elegantly dressed.

AGATHA: Have you sent for a cab, Aeneas?

POSKET: Cis is looking after that.

AGATHA: Poor Cis! How late we keep him up.

Enter CIS.

CIS: Wyke has gone for a cab, ma dear.

AGATHA: Thank you, Cis darling.

CIS: If you'll excuse me, I'll go to my room. I've another bad headache coming on.

AGATHA: *(Kissing him.)* Run along, my boy.

CIS: Good-night, ma. Good-night, Aunt Charlotte.

CHARLOTTE: Good-night, Cis.

AGATHA and CHARLOTTE look out of the window.

CIS: *(At the door.)* Ahem! Good-night, Guv.

POSKET: You've told a story – two, sir! You said you were going up to your room.

CIS: So I am – to dress.

POSKET: You said you had a bad headache coming on.

CIS: So I have, Guv. I always get a bad headache at the Hôtel des Princes. *(Goes out.)*

POSKET: Oh, what a boy!

AGATHA: *(To herself.)* When will that cab come?

POSKET: Ahem! My pet the idea has struck me that as you are going out, it would not be a bad notion for me to pop into my club.

AGATHA: The club! You were there last night.

POSKET: I know, my darling. Many men look in at their clubs every night.

AGATHA: A nice example for Cis, truly! I particularly desire that you should remain at home to-night, Aeneas.

POSKET: *(To himself.)* Oh, dear me!

CHARLOTTE: *(To AGATHA.)* Why not let him go to the club, Agatha?

AGATHA: He might meet Colonel Lukyn there.

CHARLOTTE: If Colonel Lukyn is there we shan't find him in Cork Street.

AGATHA: Then we follow him to the club.

CHARLOTTE: Ladies never call at a club.

AGATHA: Such things have been known.

Enter WYKE.

WYKE: *(Grinning behind his hand.)* The cab is coming, ma'am.

AGATHA: Coming? Why isn't it come?

WYKE: I walk quicker than the cab, ma'am. It's a good horse, slow, but very certain.

AGATHA: We will come down.

WYKE: *(To himself.)* Just what the horse has done. *(To AGATHA.)* Yes, ma'am. *(Goes out.)*

AGATHA: Good-night, Aeneas.

POSKET: *(Nervously.)* I wish you would allow me to go to the club, my pet.

AGATHA: Aeneas, I am surprised at your obstinacy. It is so very different from my first husband.

POSKET: *(Annoyed.)* Really, Agatha, I am shocked. I presume the late Mr. Farringdon occasionally used his clubs?

AGATHA: Indian clubs. Indian clubs are good for the liver; London clubs are not. Good-night!

CHARLOTTE: The first tiff. Good-night, Mr. Posket.

POSKET: Good-night, Miss Verrinder.

AGATHA and CHARLOTTE go out; POSKET paces up and down excitedly.

POSKET: Gurrh! I'm not to go to the club! I set a bad example to Cis! Ha, ha! I am different from her first husband. Yes, I am – I'm alive for one thing. I – I – I – I – I'm dashed if I don't go out with the boy.

CIS: *(Putting his head in at the door.)* Coast clear, Guv? All right.

Enter CIS, in fashionable evening dress, carrying POSKET's overcoat and hat.

Here are your hat and overcoat.

POSKET: *(Recoiling.)* Where on earth did you get that dress suit?

CIS: Mum's the word, Guv. Brighton tailor – six months' credit. He promised to send in the bill to you, so the mater

won't know. *(Putting POSKET's hat on his head.)* By Jove, Guv, don't my togs show you up?

POSKET: *(Faintly.)* I won't go, I won't go. I've never met such a boy before.

CIS: *(Proceeds to help him with his overcoat.)* Mind your arm, Guv. You've got your hand in a pocket. No, no – that's a tear in the lining. That's it.

POSKET: I forbid you to go out!

CIS: Yes, Guv. And I forbid you to eat any of those devilled oysters we shall get at the Hôtel des Princes. Now you're right!

POSKET: I am not right!

CIS: Oh, I forgot! *(He pulls out a handful of loose money.)* I found this money in your desk, Guv. You had better take it out with you; you may want it. Here you are – gold, silver, and coppers. *(He empties the money into POSKET's overcoat pocket.)* One last precaution, and then we're off.

Goes to the writing-table, and writes on a half-sheet of notepaper.

POSKET: I shall take a turn round the Square, and then come home again! I will not be influenced by a mere child! A man of my responsible position – a magistrate – supping silly at the Hôtel des Princes in Meek Street – it's horrible.

CIS: Now then – we'll creep downstairs quietly so as not to bring Wyke from his pantry. *(Giving POSKET a paper.)* You stick that up prominently, while I blow out the candles.

CIS blows out the candles on the piano.

POSKET: *(Reading.)* 'Your master and Mr. Cecil Farringdon are going to bed. Don't disturb them.' I will not be a partner to any written document. This is untrue.

CIS: No, it isn't – we are going to bed when we come home. Make haste, Guv.

POSKET: Oh, what a boy! *(Pinning the paper on to the curtain.)*

Enter WYKE.

Oh, bother!

WYKE: Going out, sir?

POSKET: *(Struggling to be articulate.)* No – yes – that is partially – half round the Square, and possibly – er – um back again. *(To CIS.)* Oh, you bad boy!

WYKE: *(Coolly going up to the paper on curtain.)* Shall I take this down now, sir?

POSKET: *(Quietly to CIS.)* I'm in an awful position! What am I to do?

CIS: Do as I do – tip him.

POSKET: What!

CIS: Tip him.

POSKET: Oh, yes – yes. Where's my money?

CIS takes two coins out of POSKET's pocket and gives them to him without looking at them.

CIS: Give him that.

POSKET: Yes.

CIS: And say – 'Wyke, you want a new umbrella – buy a very good one. Your mistress has a latch-key, so go to bed.'

POSKET: Wyke!

WYKE: Yes, sir.

POSKET: *(Giving him money.)* Go to bed – buy a very good one. Your mistress has a latch-key – so – so you want a new umbrella!

WYKE: *(Knowingly.)* All right, sir. You can depend on me. Are you well muffled up, sir? Mind you take care of him, Master Cis.

CIS: *(Supporting POSKET, who groans softly.)* Capital, Guv, capital. Are you hungry?

POSKET: Hungry! You're a wicked boy. I've told a falsehood.

CIS: No, you haven't, Guv – he really does want a new umbrella.

POSKET: Does he, Cis? Does he? Thank heaven! *(They go out.)*

WYKE: *(Looking at money.)* Here! What, twopence! *(Throws the coins down in disgust.)* I'll tell the missus.

Curtain.

Act Two

*A supper-room at the Hôtel des Princes, Meek Street, with two doors –
the one leading into an adjoining room, the other into a passage – and
a window opening on to a balcony.*

*ISIDORE, a French waiter, is showing in CIS and POSKET, who is still
very nervous and reluctant.*

CIS: Come on, Guv – come on. How are you, Isidore?

ISIDORE: I beg your pardon – I am quite well, and so are you,
zank you.

CIS: I want a pretty little light supper for myself and my friend,
Mr. Skinner.

ISIDORE: Mr. Skinner.

POSKET: *(To CIS.)* Skinner! Is someone else coming?

CIS: No, no. You're Skinner.

POSKET: Oh! *(Wanders round the room.)*

CIS: Mr. Skinner, of the Stock Exchange. What have you
ready?

ISIDORE: *(In an undertone to CIS.)* I beg your pardon – very
good – but Monsieur Blond he say to me, 'Isidore, listen
now; if Mr. Farringdon he come here, you say, I beg your
pardon, you are a nice gentleman, but will you pay your
little account when it is quite convenient, before you leave
the house at once.'

CIS: Quite so; there's no difficulty about that. What's the bill?

ISIDORE: *(Gives the bill.)* I beg your pardon. Eight pounds four
shillings.

CIS: Phew! Here go my winnings from old Bullamy and the
Guv. *(Counting out money.)* Two pounds short. *(Turning to
POSKET, who is carefully examining the scratches on the mirrors.)*
Skinner! Skinner!

POSKET: June third, the Lord Chancellor. Dear me, the Lord Chancellor patronises this house. He has scratched his name on the mirror. How very interesting.

CIS: Skinner, got any money with you?

POSKET: Yes, Cis, my boy. *(Feels for his money.)*

CIS: You always keep it in that pocket, Skinner.

POSKET: *(Taking out money.)* Oh, yes.

CIS takes two sovereigns from POSKET and gives the amount of his bill to ISIDORE, who goes to the sideboard to count out change.

Enter BLOND, a fat, middle-aged French hotel-keeper, with a letter in his hand.

ISIDORE: Monsieur Blond.

BLOND: Good evening, Mr. Farringdon.

ISIDORE: *(Quietly to BLOND.)* Ze bill is all right.

CIS: Good evening. *(Introducing POSKET.)* My friend, Mr. Harvey Skinner, of the Stock Exchange.

BLOND: Very pleased to see you. *(To CIS.)* Are you going to enjoy yourselves?

CIS: Rather.

BLOND: You usually eat in this room, but you don't mind giving it up for to-night – now, do you?

CIS: Oh, Achille!

BLOND: Come, come, to please me. A cab has just brought a letter from an old customer of mine, a gentleman I haven't seen for over twenty years, who wants to sup with a friend in this room to-night. It's quite true. *(Giving CIS a letter.)*

CIS: *(Reading to himself.)* '19A, Cork Street. Dear Blond – Fresh, or rather, stale from India – want to sup with my friend, Captain Vale, to-night, at my old table in my old room. Must do this for Auld Lang Syne. Yours, Alexander Lukyn.' Oh, let him have it. Where will you put us?

BLOND: You shall have the best room in the house, the one next to this. This room – pah! Come with me. *(To POSKET.)* Have you known Mr. Farringdon for a long time?

POSKET: No, no. Not very long.

BLOND: Ah, he is a fine fellow – Mr. Farringdon. Now, if you please. You can go through this door.

Wheels sofa away from before door and unlocks it.

CIS: *(To POSKET.)* You'll look better after a glass or two of Pommery, Guv.

POSKET: No, no, Cis – now, no champagne.

CIS: No champagne, not for my friend, Harvey Skinner! Chuck! Hey! Come, Guv – dig me in the ribs – like this. *(Digging him in the ribs.)* Chuck!

POSKET: *(Shrinking.)* Oh, don't!

CIS: And say, 'Hey!' Go on, Guv.

POSKET: I can't – I can't. I don't know what it may mean.

CIS: *(Digging him in the ribs again.)* Go on – ch – uck! Hey!

POSKET: What, like this? *(Returning the dig.)* Ch – uck. Hey!

CIS: That's it, that's it. Ha, ha! You are going it, Guv.

POSKET: *(Getting excited.)* Am I, Cis? Am I? *(Waving his arm.)* Chuck! Hey!

CIS *and* POSKET: Chuck! Hey!

CIS: Ha, ha! Come on! Serve the supper, Achille.

BLOND: Ah, he is a grand fellow, Mr. Farringdon! *(CIS and POSKET go into the other room. To ISIDORE.)* Replace the canapé.

There is a sharp knock at the other door. BLOND follows CIS and POSKET into the other room, then locks the door on the inside.

ISIDORE: Come in, please.

Enter COLONEL LUKYN and CAPTAIN VALE. LUKYN is a portly, grey-haired, good-looking military man; VALE is pale-faced and heavy-eyed, while his manner is languid and dejected.

LUKYN: This is the room. Come in, Vale. This is my old supper-room – I haven't set foot here for over twenty years. By George, I hope to sup here for another twenty.

VALE: *(Dejectedly.)* Do you? In less than that, unless I am lucky enough to fall in some foreign set-to, I shall be in Kensal Green.

LUKYN: *(Looking round the room sentimentally.)* Twenty years ago! Confound 'em, they've painted it.

VALE: My people have eight shelves in the Catacombs at Kensal Green.

LUKYN: Nonsense, man, nonsense. You're a little low. Waiter, take our coats.

VALE: Don't check me, Lukyn. My shelf is four from the bottom.

LUKYN: You'll forget the number of your shelf before you're half-way through your oysters.

VALE: *(Shaking his head.)* An oyster merely reminds me of my own particular shell.

ISIDORE begins to remove VALE's coat.

LUKYN: Ha, ha! Ha, ha!

VALE: Don't, Lukyn, don't. *(In an undertone to LUKYN.)* It's very good of you, but by Jove, my heart is broken. *(To ISIDORE.)* Mind my flower, waiter, confound you.

He adjusts flower in his button-hole.

ISIDORE: You have ordered supper, sir?

LUKYN: Yes, on the back of my note to Mr. Blond. Serve it at once.

ISIDORE: I beg your pardon, sir, at once. *(Goes out.)*

LUKYN: So, you've been badly treated by a woman, eh, Vale?

VALE: Shockingly. Between man and man, a Miss Verrinder –
Charlotte. *(Turning away.)* Excuse me, Lukyn.

*Produces a folded silk handkerchief, shakes it out, and gently blows
his nose.*

LUKYN: *(Lighting a cigarette.)* Certainly – certainly – does you
great credit. Pretty woman?

VALE: Oh, lovely! A most magnificent set of teeth. All real, as
far as I can ascertain.

LUKYN: No!

VALE: Fact.

LUKYN: Great loss – have a cigarette.

VALE: *(Taking case from LUKYN.)* Cork tips?

LUKYN: Yes. Was she – full grown?

VALE: *(Lighting his cigarette.)* Just perfection. She rides eight
stone fifteen, and I have lost her, Lukyn. Beautiful tobacco.

LUKYN: What finished it?

VALE: She gave a man a pair of worked slippers three days
after our engagement.

LUKYN: No!

VALE: Fact. You remember Bristow – Gordon Bristow?

LUKYN: Perfectly. Best fellow in the world.

VALE: He wears them.

LUKYN: Villain! Will you begin with a light wine, or go right
on to the champagne?

VALE: By Jove, it's broken my heart, old fellow. I'll go right
on to the champagne, please. Lukyn, I shall make you my
executor.

LUKYN: Pooh! You'll outlive me! Why don't they bring the
supper? My heart has been broken like yours. It was

broken first in Ireland in '55. It was broken again in London in '61, but in 1870 it was smashed in Calcutta, by a married lady that time.

VALE: A married lady?

LUKYN: Yes, my late wife. Talk about broken hearts, my boy, when you've won your lady, not when you've lost her.

Enter ISIDORE, with a tray of supper things.

The supper. *(To VALE.)* Hungry?

VALE: *(Mournfully.)* Very.

Enter BLOND, with an envelope.

BLOND: Colonel Lukyn.

LUKYN: Ah, Blond, how are you? Not a day older. What have you got there?

BLOND: *(Quietly to LUKYN in an undertone.)* Two ladies, Colonel, downstairs in a cab, must see you for a few minutes alone.

LUKYN: Good gracious! Excuse me, Vale. *(Takes the envelope from BLOND and opens it: reading the enclosed card.)* Mrs. Posket – Mrs. Posket! 'Mrs. Posket entreats Colonel Lukyn to see her for five minutes upon a matter of urgent necessity, and free from observation.' By George! Posket must be ill in bed – I thought he looked seedy last night. *(To BLOND.)* Of course – of course. Say I'll come down.

BLOND: It is raining outside. I had better ask them up.

LUKYN: Do – do. I'll get Captain Vale to step into another room. Be quick. Say I am quite alone.

BLOND: Yes, Colonel. *(Hurries out.)*

CIS: *(In the next room, rattling glasses and calling.)* Waiter! Waiter! Waiter-r-r! Where the deuce are you?

ISIDORE: Coming, sir, coming. I beg your pardon. *(Bustles out.)*

LUKYN: My dear Vale, I am dreadfully sorry to bother you. Two ladies, one the wife of a very old friend of mine, have

followed me here and want half a dozen words with me alone. I am in your hands – how can I manage it?

VALE: My dear fellow, don't mention it. Let me go into another room.

LUKYN: Thank you very much. You're so hungry too.

VALE: All right. I'll pop in here.

He passes behind sofa and tries the door leading into the other room.

CIS: *(Within.)* What do you want? Who's there?

VALE: Occupied – never mind – I'll find my way somewhere.

There is a knock; VALE draws back.

BLOND: *(Without.)* Colonel, are you alone? The ladies.

LUKYN: One moment. Deuce take it, Vale! The ladies don't want to be seen. By George – I remember. There's a little balcony to that window; step out for a few moments – keep quiet – I shan't detain you – it's nothing important – husband must have had a fit or something.

VALE: Oh, certainly!

LUKYN: Good fellow – here's your hat.

In his haste he fetches his own hat.

BLOND: *(Outside, knocking.)* Colonel, Colonel!

LUKYN: One moment. *(Giving his hat to VALE.)* Awfully sorry. You're so hungry too. *(VALE puts on the hat, which is much too large for him.)* Ah, that's my hat.

VALE: My dear Lukyn – don't mention it.

Opening the window and going out.

LUKYN: *(Drawing the curtain over the recess.)* Just room for him to stand like a man in a sentry-box. Come in, Blond.

BLOND shows in AGATHA and CHARLOTTE, both wearing veils.

AGATHA: *(Agitated.)* Oh, Colonel Lukyn!

LUKYN: Pray compose yourself, pray compose yourself!

AGATHA: What will you think?

LUKYN: *(Holding out his hand, gallantly.)* That I am perfectly enchanted.

AGATHA: Thank you. *(Pointing to CHARLOTTE.)* My sister.

LUKYN and CHARLOTTE bow.

LUKYN: Be seated. Blond? *(Softly to him.)* Keep the waiter out till I ring – that's all. *(The loud pattering of rain is heard.)*

BLOND. Yes, Colonel.

LUKYN: Good gracious, Blond! What's that?

BLOND. The rain outside. It is cats and dogs.

LUKYN: *(Horrified.)* By George, is it? *(To himself, looking towards window.)* Poor devil! *(To BLOND, anxiously.)* There isn't any method of getting off that balcony, is there?

BLOND: No – unless by getting on to it.

LUKYN: What do you mean?

BLOND: It is not at all safe. Don't use it.

LUKYN stands horror-stricken; BLOND goes out. Heavy rain is heard.

LUKYN: *(After some nervous glances at the window, wiping perspiration from his forehead.)* I am honoured, Mrs. Posket, by this visit – though for the moment I can't imagine –

AGATHA: Colonel Lukyn, we drove to Cork Street to your lodgings, and there your servant told us you were supping at the Hôtel des Princes with a friend. No one will be shown into this room while we are here?

LUKYN: No – we – ah – shall not be disturbed. *(To himself.)* Good heavens, suppose I never see him alive again!

AGATHA: *(Sighing wearily.)* Ah!

LUKYN: I'm afraid you've come to tell me Posket is ill.

AGATHA: I – no – my husband is at home.

A sharp gust of wind is heard with the rain.

LUKYN: *(Starts.)* Lord forgive me! I've killed him.

AGATHA: *(With horror.)* Colonel Lukyn!

LUKYN: *(Confused.)* Madam!

AGATHA: Indeed, Mr. Posket is at home.

LUKYN: *(Glancing at the window.)* Is he? I wish we all were.

AGATHA: *(To herself.)* Sunstroke, evidently. Poor fellow! *(To LUKYN.)* I assure you my husband is at home, quite well, and by this time sleeping soundly.

CIS and POSKET are heard laughing in the next room.

ISIDORE: *(Within.)* You are two funny gentlemen, I beg your pardon.

AGATHA: *(Startled.)* What is that?

LUKYN: In the next room. *(Raps at the door.)* Hush – hush, hush!

CHARLOTTE: Get it over Aggy, and let us go home. I am so awfully hungry.

LUKYN: *(Peering through the curtains.)* It is still bearing him. What's his weight? Surely he can't scale over ten stone. Lord, how wet he is!

AGATHA: Colonel Lukyn!

LUKYN: Madam, command me!

AGATHA: Colonel Lukyn, we knew each other at Baroda twenty years ago.

LUKYN: When I look at you, impossible.

AGATHA: Ah, then you mustn't look at me.

LUKYN: Equally impossible.

CHARLOTTE: *(To herself.)* Oh, I feel quite out of this.

AGATHA: You were at my little boy's christening?

LUKYN: *(Absently.)* Yes – yes – certainly.

AGATHA: You remember what a fine little fellow he was.

LUKYN: *(Thoughtfully.)*. Not a pound over ten stone.

AGATHA: Colonel Lukyn!

LUKYN: *(Recovering himself.)* I beg your pardon, yes – I was at the christening of your boy.

AGATHA: *(To herself.)* One of the worst cases of sunstroke I have ever known.

LUKYN: I remember the child very well. Has he still got that absurd mug?

AGATHA: Colonel Lukyn!

LUKYN: Madam!

AGATHA: My child is, and always was perfect.

LUKYN: You misunderstand me! I was his godfather; I gave him a silver cup.

AGATHA: Oh, do excuse me. *(Wiping her eyes.)* How did I become acquainted with such a vulgar expression? I don't know where I pick up my slang. It must be through loitering at shop windows. Oh, oh, oh!

LUKYN: Pray compose yourself. I'll leave you for a moment.

Going to the window.

AGATHA: How shall I begin, Charley?

CHARLOTTE: Make a bold plunge, do! The odour of cooking here, to a hungry woman, is maddening.

VALE softly opens the window and comes into the recess, but remains concealed by the curtain from those on the stage.

VALE: *(To himself.)* This is too bad of Lukyn! I'm wet to the skin and frightfully hungry! Who the deuce are these women?

AGATHA: Colonel Lukyn!

LUKYN: Madam. *(Listening.)* No crash yet.

AGATHA: *(Impulsively laying her hand upon his arm.)* Friend of twenty years! I will be quite candid with you. You are going to dine with us to-morrow?

LUKYN: Madam, I will repay your candour as it deserves. I am.

AGATHA: My husband knows of your acquaintance with the circumstances of my first marriage. I know what men are. When the women leave the dinner – table, men become retrospective. Now, to-morrow night, over dessert, I beg you not to give my husband dates.

LUKYN: *(Astonished.)* I beg your pardon?

AGATHA: Keep anything like dates from him.

LUKYN: *(Puzzled.)* Mustn't eat stone fruit?

AGATHA: No, I mean years, months, days – dates connected with my marriage with Mr. Farringdon.

LUKYN: Dear me, sore subject!

AGATHA: I will be more than candid with you. My present husband, having a very short vacation in the discharge of his public duties, wooed me but for three weeks; you, who have in your time courted and married, know the material of which that happy period is made up. The future is all engrossing to the man; the presents – I mean the present, a joyous dream to the woman. But in dealing with my past I met with more than ordinary difficulties.

LUKYN: Don't see why. Late husband died a natural death. Wasn't stood on a balcony or anything.

AGATHA: Colonel Lukyn, you know I was six-and-thirty at the time of my recent marriage!

LUKYN: You surprise me!

AGATHA: You know it! Be frank, Lukyn! Am I not six-and-thirty?

LUKYN: You are.

AGATHA: Very well, then. In a three weeks' engagement how was it possible for me to deal with the various episodes of six-and-thirty years? The past may be pleasant, golden, beautiful – but one may have too much of a good thing.

LUKYN: *(To himself.)* I am in that position now.

AGATHA: The man who was courting me was seeking relaxation from the discharge of multifarious responsibilities. How could I tax an already wearied attention with the recital of the events of thirty-six years?

LUKYN: What did you do?

AGATHA: Out of consideration for the man I loved, I sacrificed five years of happy girlhood – told him I was but one-and-thirty – that I had been married only fifteen years previously – that my boy was but fourteen!

LUKYN: By George, madam, and am I to subscribe to all this?

AGATHA: I only ask you to avoid the question of dates.

LUKYN: But at a man's dinner-table –

AGATHA: You need not spoil a man's dinner. *(Appealingly.)* Not only a man's – but a woman's! Lukyn, Lukyn! Promise!

LUKYN: Give me a second to think.

LUKYN, turning away, discovers CHARLOTTE in the act of lifting the covers from the dishes and inspecting the contents.

LUKYN: Ah, devilled oysters!

CHARLOTTE: Oh!

Drops dish-cover with a crash, and runs over to the table and speaks to AGATHA.

LUKYN: Don't go – pray look at 'em again. *(To himself.)* What am I to do? Shall I promise? Poor Posket! If I don't promise, she'll cry and won't go home. The oysters are nearly cold – cold! What must *he* be! *(Drawing aside the curtain and not seeing VALE, he staggers back.)* Gone – and without a cry – brave fellow, brave fellow!

AGATHA: Colonel Lukyn.

LUKYN: *(To himself.)* Decay of stamina in the army – pah! The young 'uns are worthy of our best days.

AGATHA: Colonel Lukyn, will you promise?

LUKYN: Promise? Anything, my dear madam, anything.

AGATHA: Ah, thank you! May I ask you to see us to our cab?

LUKYN: Certainly! Thank heaven, they're going!

AGATHA: *(To CHARLOTTE.)* It's all right; come along.

CHARLOTTE: *(To AGATHA.)* Oh, those oysters look so nice.

LUKYN: *(To himself.)* Stop! In my trouble, I am forgetting even the commonest courtesies to these ladies. *(To AGATHA.)* You have a long journey before you. I am sure your husband would not forgive me for letting you face such weather unprepared. Let me recommend an oyster or two and a thimbleful of champagne.

AGATHA: No thank you, Colonel Lukyn.

CHARLOTTE: *(To AGATHA.)* Say yes. I'm starving.

LUKYN: As you please. *(To himself.)* I knew they'd refuse. I've done my duty.

CHARLOTTE: *(To AGATHA.)* I was in the train till seven o'clock – accept.

AGATHA: Ahem! Colonel, the fact is my poor sister has been travelling all day and is a little exhausted.

LUKYN: *(Horrified.)* You don't mean to say you're going to give me the inestimable pleasure. *(CHARLOTTE looks across at him, nodding and smiling.)* I am delighted.

CHARLOTTE sits hungrily at table; LUKYN fetches a bottle of champagne from the sideboard.

AGATHA: Charlotte, I am surprised.

CHARLOTTE: Nonsense, the best people come here. Some of them have left their names on the mirrors.

VALE: *(Behind the curtain.)* This is much too bad of Lukyn. What are they doing now? *(LUKYN draws the cork.)* Confound it, they're having my supper! *(LUKYN pours out wine.)*

CHARLOTTE: Why doesn't he give me something to eat?

There is a clatter of knives and forks heard from the other room, then a burst of laughter from CIS.

AGATHA: *(Starting.)* Charley, hark! How strange!

CHARLOTTE: Very. This bread is beautiful.

CIS is heard singing the chorus of a comic song boisterously.

CIS: I shall never forget my Nancy.

I shall never forget her wiles;

But I'm sorry that I introduced her

To the Duke of Seven Dials.

Now then Guv!

AGATHA: Don't you recognise that voice?

CHARLOTTE: *(Munching.)* The only voice I recognise is the voice of hunger.

AGATHA: I am overwrought, I suppose.

LUKYN, with his head drooping, fetches the dish of oysters from the sideboard.

VALE: *(Behind the curtain.)* He has taken the oysters. I've seen him do it.

LUKYN: The oysters.

LUKYN sinks into his chair at the table and leans his head upon his hand; the two women look at each other.

CHARLOTTE: *(To AGATHA.)* Anything wrong?

AGATHA: *(Tapping her forehead.)* Sunstroke – bad case!

CHARLOTTE: Oh – poor fellow. *(She gently lifts the corner of the dish, sniffs, then replaces cover.)* No plates.

AGATHA: Ask for them.

CHARLOTTE: You ask.

AGATHA: You're hungry.

CHARLOTTE: You're married. Comes better from you.

VALE: *(Behind curtain.)* This silence is terrible.

AGATHA: *(To LUKYN.)* Ahem! Ahem!

LUKYN: *(Looking up suddenly.)* Eh?

AGATHA: *(Sweetly.)* There are no plates.

LUKYN: *(Rousing himself.)* No plates? No plates? It's my fault. Pardon me. Where are the plates?

VALE, still invisible, stretches out his hand through the curtain, takes up the plates and presents them to LUKYN, who recoils

VALE: *(In a whisper.)* Here are the plates. Look sharp, Lukyn.

LUKYN: *(With emotion.)* Vale! Safe and sound! *(He takes the plates, then grasps VALE's extended hand.)* Bless you, old fellow. I'm myself again. *(Going gaily to the table with the plates.)* My dear ladies, I blush – I positively blush – I am the worst host in the world.

VALE: *(To himself.)* By Jove, that's true.

AGATHA: Not at all – not at all.

LUKYN: *(Helping the ladies.)* I'll make amends, by George! You may have noticed I've been confoundedly out of sorts. That's my temperament – now up, now down. I've just taken a turn, ha, ha! Oysters. *(Handing plate to AGATHA.)*

AGATHA: Thank you.

LUKYN: Ah, I've passed many a happy hour in this room. The present is not the least happy.

CHARLOTTE: *(Trying to attract his attention.)* Ahem! Ahem!

LUKYN: *(Gazing up at the ceiling.)* My first visit to the Hôtel des Princes was in the year – the year – let me think.

CHARLOTTE: *(Tearfully whispering to AGATHA.)* Isn't he going to help me?

LUKYN: Was it in '55?

AGATHA: *(Quickly passing her plate over to CHARLOTTE.)* I'm not hungry.

CHARLOTTE: You're a dear.

LUKYN: *(Emphatically.)* It *was* in '55. I'm forgetful again pardon me. *(He hands plate of oysters to CHARLOTTE, and is surprised to find her eating vigorously.)* Why, I thought I – *(To AGATHA.)* My dear madam, a thousand apologies. *(He helps her and then himself.)* Pah! They're cold – icy – You could skate on 'em. There's a dish of something else over there.

He goes to the sideboard; VALE's hand is again stretched forth with the other covered dish.

VALE: I say, Lukyn.

LUKYN: *(Taking the dish.)* Thanks, old fellow. *(He returns to the table and lifts the cover.)* Soles – they look tempting. If there are only some lemons! Surely they are not so brutal as to have forgotten the lemons. Where are they? *(He returns to the sideboard.)* Where are they? *(In an undertone to VALE.)* Have you seen any lemons?

AGATHA: Pray, think less of us, Colonel Lukyn. Let me take care of you.

LUKYN: You're very kind. I wish you would let me ring for some lemons.

VALE's hand comes as before from behind the curtain to the sideboard, finds the dish of lemons, and holds it out at arm's length.

VALE: *(In a whisper.)* Lemons.

AGATHA is helping LUKYN, when suddenly CHARLOTTE, with her fork in the air, leans back open-mouthed, staring wildly at VALE's arm extended with the dish.

CHARLOTTE: *(In terror.)* Agatha! Agatha!

AGATHA: Charlotte! What's the matter, Charley?

CHARLOTTE: Agatha!

AGATHA: You're ill, Charlotte! Surely you are not choking?

CHARLOTTE: *(Pointing to the curtain.)* Look, look!

They both scream.

LUKYN: Don't be alarmed – I –

CHARLOTTE *and* AGATHA: *(Together.)* Who's that?

LUKYN: I can explain. Don't condemn till you've heard. I – I –

Damn it, sir, put those lemons down!

CHARLOTTE: He calls him 'Sir' – it must be a man.

LUKYN: It is a man. I am not in a position to deny that.

AGATHA: Really, Colonel Lukyn!

LUKYN: It is my friend. He – he – he's merely waiting for his supper.

AGATHA: *(Indignantly.)* Your friend! *(To CHARLOTTE.)* Come home, dear.

LUKYN: Do, do hear me! To avoid the embarrassment of your encountering a stranger, he retreated to the balcony.

AGATHA: *(Contemptuously.)* To the balcony? You have shamefully compromised two trusting women, Colonel Lukyn.

LUKYN: *(Energetically.)* I would have laid down my life rather than have done so. I did lay down my friend's life.

AGATHA: He has overheard every confidential word I have spoken to you.

LUKYN: Hear his explanation. *(To the curtain.)* Why the devil don't you corroborate me, sir?

VALE: *(From behind the curtain.)* Certainly. I assure you I heard next to nothing.

CHARLOTTE: *(Grasping AGATHA's arm.)* Oh, Agatha!

VALE: I didn't come in till I was exceedingly wet.

LUKYN: *(To AGATHA.)* You hear that?

VALE: And when I did come in –

CHARLOTTE: *(Hysterically.)* Horace!

VALE: I beg your pardon.

CHARLOTTE: It's Horace, Captain Vale.

VALE: *(Coming from behind the curtain, looking terribly wet.)* Charlotte – Miss Verrinder.

CHARLOTTE: What are you doing here? What a fright you look.

VALE: What am I doing here, Miss Verrinder? Really, Lukyn, your conduct calls for some little explanation.

LUKYN: My conduct, sir?

VALE: You make some paltry excuse to turn me out in the rain explanation to while you entertain a lady who you know has very recently broken my heart.

LUKYN: I didn't know anything of the kind.

VALE: I told you, Colonel Lukyn – this isn't the conduct of an officer and a gentleman.

LUKYN: Whose isn't, yours or mine?

VALE: Mine. I mean yours.

LUKYN: You are in the presence of ladies, sir; take off my hat.

VALE: I beg your pardon. I didn't know I had it on.

He throws the hat away, and the two men exchange angry words.

CHARLOTTE: He's a very good-looking fellow; you don't see a man at his best when he's wet through.

AGATHA: *(Impatiently.)* Colonel Lukyn, do you ever intend to send for a cab?

LUKYN: Certainly, madam.

VALE: One moment. I have some personal exchange with Miss Verrinder.

CHARLOTTE: *(To AGATHA.)* The slippers. *(To VALE.)* I am quite ready, Captain Vale.

VALE: Thank you. Colonel Lukyn, will you oblige me by stepping out on to that balcony?

LUKYN: *(Hotly.)* Certainly not, sir.

VALE: You're afraid of the wet, Colonel Lukyn; you are no soldier.

LUKYN: You know better, sir. As a matter of fact, that balcony can't bear a man like me.

VALE: Which shows that inanimate objects have a great deal of common sense, sir.

LUKYN: You don't prove it in your own instance, Captain Vale.

VALE: That's a verbal quibble, sir. *(They talk angrily.)*

AGATHA: *(To CHARLOTTE.)* It's frightfully late. Tell him to write to you.

CHARLOTTE: I must speak to him to-night; life is too short for letters.

AGATHA: Then he can telegraph.

CHARLOTTE: Too expensive.

AGATHA: Very well, then, Lady Jenkins has a telephone. I'll take you there to tea to-morrow. If he loves you, tell him to ring up Regent 50875.

CHARLOTTE: You thoughtful angel!

LUKYN: Mrs. Posket – Miss Verrinder – ahem – we –

VALE: Colonel Lukyn and myself –

LUKYN: Captain Vale and I fear that we have been betrayed, in a moment of –

VALE: Natural irritation.

LUKYN: Natural irritation, into the atrocious impropriety of differing –

VALE: Before ladies.

LUKYN: Charming ladies –

VALE: We beg your pardon – Lukyn!

LUKYN: Vale! *(They grasp hands.)* Mrs. Posket, I am now going out to hail a cab.

AGATHA: Pray do.

LUKYN: Miss Verrinder, the process will occupy five minutes.

VALE: *(Giving his hat to LUKYN.)* Lukyn, I return your kindness – my hat.

LUKYN: Thank you, my boy.

LUKYN puts on VALE's hat, which is much too small for him. As he is going out there is a knock at the door; he opens it: BLOND is outside.

BLOND: Colonel, it is ten minutes past the time of closing; may I ask you to dismiss your party?

LUKYN: Pooh! Isn't this a free country? *(Goes out.)*

BLOND: Yes, you are free to go home, Colonel. I shall get into trouble. *(Following him out.)*

CHARLOTTE: *(To AGATHA.)* I'll have the first word. Really, Captain Vale, I'm surprised at you.

VALE: There was a happy time, Miss Verrinder, when I might have been surprised at you.

CHARLOTTE: A few hours ago it was – 'By Jove, all is over.' Now I find you with a bosom friend enjoying devilled oysters.

VALE: I beg your pardon; I find you enjoying devilled oysters.

CHARLOTTE: *(Haughtily.)* Horace Vale, you forget you have forfeited the right to exercise any control over my diet.

VALE: One would think I had broken off our engagement.

CHARLOTTE: If you have not, who has? I have your letter saying all is over between us. *(Putting her handkerchief to her eyes.)* That letter will be stamped tomorrow at Somerset House. *(With sobs.)* I know how to protect myself.

VALE: Charlotte, can you explain your conduct with Gordon Bristow?

CHARLOTTE: I could if I chose; a young lady can explain anything.

VALE: But he is showing your gift to our fellows all over the place.

CHARLOTTE: It was a debt of honour. He bet me a box of gloves against a pair of slippers about 'Forked Lightning' for the Regimental Stakes, and 'Forked Lightning' went tender at the heel. I couldn't come to you with debts hanging over me. *(Crying.)* I'm too conscientious.

VALE: By Jove, I've been a brute.

CHARLOTTE: Y-y-yes.

VALE: Can you forget I ever wrote that letter?

CHARLOTTE: That must be a question of time. *(She lays her head on his shoulder and then removes it.)* How damp you are! *(She puts her handkerchief upon his shoulder, and replaces her head. She moves his arm gradually up and arranges it round her shoulder.)* If you went on anyhow every time I discharged an obligation, we should be most unhappy.

VALE: I promise you I won't mention Bristow's slippers again. By Jove, I won't – there.

CHARLOTTE: Very well, then, if you do that I'll give you my word I won't pay any more debts before our marriage.

VALE: My darling!

CHARLOTTE: *(About to embrace him, but remembering that he is wet.)* No – no – you are too damp.

ISIDORE: *(Outside.)* I beg your pardon; it is a quarter of an hour over our time.

AGATHA has been sitting on the sofa; suddenly she starts, listening intently.

POSKET: *(Outside.)* I know – I know. I'm going directly I can get the boy away.

AGATHA: *(To herself.)* Aeneas!

CIS: *(Outside.)* All right, Guv, you finish your bottle.

AGATHA: My boy!

ISIDORE: *(Outside.)* Gentlemen, come – come.

AGATHA: *(To herself.)* Miserable deceiver! This, then, is the club, and the wretched man conspires to drag my boy down to his own awful level. What shall I do? I daren't make myself known here. I know; I'll hurry home, and if I reach there before Aeneas, which I shall do, *(Clenching her fist.)* I'll sit up for him.

Enter LUKYN.

AGATHA: *(Excitedly.)* Is the cab at the door?

LUKYN: It is.

AGATHA: Charlotte! Charlotte! *(Drawing her veil down.)*

CHARLOTTE: I'm ready dear. *(To VALE.)* Married sisters are always a little thoughtless.

VALE: *(Offering his arm.)* Permit me.

LUKYN: *(Offering his arm to AGATHA.)* My dear madam.

They are all four about to leave when BLOND enters hurriedly.

BLOND: *(Holding up his hand for silence.)* Hush! Hush!

LUKYN: What's the matter?

BLOND: The police!

ALL: *(In a whisper.)* The police!

BLOND: *(Quietly.)* The police are downstairs at the door. I told you so.

CHARLOTTE: *(Clinging to VALE.)* Oh, dear! Oh, dear!

AGATHA: Gracious powers!

BLOND: Keep quiet, please. They may be satisfied with Madame Blond's assurances. I must put you in darkness; they can see the light here if they go round to the back.

Blows out candles, and turns down the other lights.

AGATHA *and* CHARLOTTE: Oh!

BLOND: Keep quiet, please! My licence is once marked already. Colonel Lukyn, thank you for this. *(He goes out.)*

AGATHA: *(Whimpering.)* Miserable men! What have you done? Are you criminals?

CHARLOTTE: You haven't deserted or anything on my account, have you, Horace?

LUKYN: Hush! Don't be alarmed. Our time has passed so agreeably that we have overstepped the prescribed hour for closing the hotel. That's all.

AGATHA: What can they do to us?

LUKYN: At the worst, take our names and addresses, and summon us for being here during prohibited hours.

AGATHA: *(Faintly.)* Oh!

CHARLOTTE: Horace, can't you speak?

VALE: By Jove, I very much regret this.

Enter ISIDORE.

LUKYN: Well, well?

ISIDORE: I beg your pardon; the police have come in.

LUKYN: The devil! *(To AGATHA.)* My dear lady, don't faint at such a moment.

Enter BLOND quickly, carrying a rug.

BLOND: They are going over the house! Hide!

AGATHA *and* CHARLOTTE: Oh!

There is a general commotion.

BLOND: They have put a man at the back. Keep away from the window.

They are all bustling, and everybody is talking in whispers; LUKYN places AGATHA under the table, where she is concealed by the cover; he gets behind the overcoats hanging from the pegs; VALE and CHARLOTTE crouch down behind sofa.

Thank you very much. I am going to put Isidore to bed on the sofa. That will explain the light which has just gone out. *(ISIDORE quietly places himself upon the sofa; BLOND covers him with the rug.)* Thank you very much. *(He goes out.)*

AGATHA: *(In a stifled voice.)* Charley! Charley!

CHARLOTTE: Yes.

AGATHA: Where are you?

CHARLOTTE: Here.

AGATHA: Oh, where is Captain Vale?

CHARLOTTE: I think he's near me.

VALE: By Jove, Charlotte, I am!

AGATHA: Colonel Lukyn!

LUKYN: *(From behind the coats.)* Here, madam!

AGATHA: Don't leave us.

LUKYN: Madam, I am a soldier.

CHARLOTTE: Oh, Horace, at such a moment what a comfort we must be to each other.

VALE: My dear Charlotte, it's incalculable.

ISIDORE gently raises himself and looks over the back of sofa.

CHARLOTTE: *(In terror.)* What's that?

ISIDORE: *(Softly.)* I beg your pardon. *(He sinks back.)*

Enter BLOND quietly, followed by CIS and POSKET on tip-toe, POSKET holding on to CIS.

BLOND: This way; be quick. Excuse me, the police are just entering the room in which these gentlemen were having supper. One of them is anxious not to be asked any questions. Please to hide him and his friend somewhere. They are both very nice gentlemen. *(He goes out, leaving CIS and POSKET.)*

POSKET: Cis, Cis! Advise me, my boy, advise me.

CIS: It's all right, Guv, it's all right. Get behind something.

AGATHA: *(Peeps from under the tablecloth.)* Aeneas, and my child!

POSKET and CIS wander about, looking for hiding-places.

VALE: *(To CIS.)* Go away.

CIS: Oh!

LUKYN: *(To POSKET, who is fumbling at the coats.)* No, no.

BLOND: *(Popping his head in.)* The police – coming!

CIS disappears behind the window-curtain. POSKET dives under the table.

AGATHA: Oh!

POSKET: *(To AGATHA in a whisper.)* I beg your pardon. I think I am addressing a lady. I am entirely the victim of circumstances. Accept my apologies for this apparent intrusion. *(No answer.)* Madam, I applaud your reticence, though any statement made under the present circumstances would not be used against you. *(Looking out.)* Where is that boy? *(Disappearing suddenly.)* Oh! Madam,

it may be acute nervousness on your part, but you are certainly pinching my arm.

There is the sound of heavy feet outside, then enter MESSITER, a gruff matter-of-fact Inspector of Police, followed by HARRIS, a constable, and BLOND.

BLOND: *You* need not trouble yourself – take my word for it.

MESSITER: No trouble, Mr. Blond, thank you. *(Sniffing.)* Candles – blown out – lately. This is where the light was.

BLOND: Perhaps. My servant, Isidore, sleeps here; he has only just gone to bed.

MESSITER: Oh!

Taking a bull's-eye lantern from HARRIS and throwing the light on ISIDORE, who is apparently sleeping soundly.

Dead tired, I suppose?

BLOND: I suppose so.

MESSITER: *(Slightly turning down the covering.)* He sleeps in his clothes?

BLOND: Oh, yes.

MESSITER: Always?

BLOND: Always – it is a rule of the hotel.

MESSITER: Oh – why's that?

BLOND: To be ready for the morning.

MESSITER: All right – all right. *(Throwing the rug and blanket aside.)* Isidore, go downstairs and give your full name and particulars to Sergeant Jarvis.

ISIDORE: *(Rising instantly.)* Yes, sir – very good.

BLOND: *(To ISIDORE.)* Why do you wake up so soon? Devil take you!

ISIDORE: I beg your pardon. *(Goes out.)*

MESSITER: What is underneath that window, Mr. Blond?

BLOND: The skylight over the kitchen – devil take it!

MESSITER: Thank you – *you* can go down to the sergeant now, Mr. Blond.

BLOND: With pleasure – devil take me!

MESSITER: Now then, Harris.

HARRIS: Yes, sir.

MESSITER: Keep perfectly still and hold your breath as long as you can.

HARRIS: Hold my breath, Sir?

MESSITER: Yes – I want to hear how many people are breathing in this room. Are you ready?

HARRIS: Yes, sir.

MESSITER: Go! *(HARRIS stands still, tightly compressing his lips; MESSITER quickly examines his face by the light of the lantern, then walks round the room, listening, and nodding his head with satisfaction as he passes the various hiding-places. HARRIS writhes in agony; in the end he gives it up and breathes heavily.)* Harris!

HARRIS: *(Exhausted.)* Yes, sir!

MESSITER: You're breathing.

HARRIS: Oh lor', yes, sir!

MESSITER: You'll report yourself to-night!

HARRIS: I held on till I nearly went off, sir.

MESSITER: *(Giving him the bull's-eye.)* Don't argue, but light up. There are half a dozen people concealed in this room. *(There is a cry from the women. CHARLOTTE and VALE rise; LUKYN steps from behind the coats.)* I thought so.

As MESSITER turns, AGATHA and POSKET rise, CIS comes quickly, catches hold of POSKET, and drags him across to the window.

CIS: Come on, Guv, Come on!

They disappear through the curtain as HARRIS turns up the lights. Then there is a cry and the sound of a crash.

AGATHA: *(Sinking into chair.)* They're killed!

MESSITER: *(Looks through the window.)* No, they're not; they've gone into the kitchen and the balcony with them. Look sharp, Harris. *(HARRIS goes out quickly.)*

LUKYN: *(To MESSITER.)* I shall report you for this, sir.

MESSITER: *(Taking out his note-book.)* Very sorry, sir; it's my duty.

LUKYN: Duty, sir! Coming your confounded detective tricks on ladies and gentlemen! How dare you make ladies and gentlemen suspend their breathing till they nearly have apoplexy? Do you know I'm a short-necked man, sir?

MESSITER: I didn't want you to leave off breathing, sir. I wanted you to breathe louder. Your name and address, sir.

LUKYN: Gur-r-r-h!

MESSITER: *(Coaxingly.)* Army gentleman, sir?

LUKYN: How do you know that?

MESSITER: Short style of speaking, sir. Army gentlemen run a bit brusquish when on in years.

LUKYN: Oh! *(Conquering himself.)* Alexander Lukyn – Colonel Her Majesty's Cheshire Light Infantry, late 41st Foot, 3rd Battalion – Bengal – Retired.

MESSITER: *(Writing.)* Hotel or club, Colonel?

LUKYN: Neither. 19A, Cork Street-lodgings.

MESSITER: *(Writing.)* Very nice part, Colonel. Thank you.

LUKYN: Bah!

MESSITER: Other gentleman?

VALE: *(With languid hauteur.)* Horace Edmund Cholmeley Clive Napier Vale – Captain – Shropshire Fusiliers – Stark's Hotel, Conduit Street.

MESSITER: *(Writing.)* Retired, sir?

VALE: No, confound you – active!

MESSITER: Thank you, Captain. Ahem! Beg pardon. The – the ladies.

CHARLOTTE clings to VALE, AGATHA to LUKYN.

AGATHA *and* CHARLOTTE: No – no! No – no!

LUKYN: *(To AGATHA.)* All right – all right – trust to me! *(To MESSITER.)* Well, sir?

MESSITER: Names and addresses, please.

LUKYN: *(Pacifically.)* Officer – my good fellow – tell me now – er – um – at the present moment, *(putting his hand in his pocket.)* what are you most in want of?

MESSITER: These two ladies' names and addresses, please. Be quick, Colonel. *(Pointing to AGATHA.)* That lady first.

LUKYN: *(With an effort.)* Christian names – er – ah – er – Alice Emmeline.

MESSITER: *(Writing.)* Alice Emmeline. Surname?

LUKYN: Er – um – Fitzgerald – 101, Wilton Street, Piccadilly.

MESSITER: Single lady?

LUKYN: Quite.

MESSITER: Very good, sir.

AGATHA: *(To LUKYN, tearfully.)* Oh, thank you, such a nice address too.

MESSITER: *(To VALE.)* Now Captain, please – that lady.

VALE: *(Who has been reassuring CHARLOTTE.)* Haw – ah – this lady is – ah – um – the other lady's sister.

MESSITER: Single lady, sir?

VALE: Certainly.

MESSITER: *(Writing.)* Christian name, Captain?

VALE: Ah – um – Harriet.

MESSITER: *(Writing.)* Surname?

VALE: Er – Macnamara.

MESSITER: *(With a grim smile.)* Quite so. Lives with her sister, of course, sir?

VALE: Of course.

MESSITER: Where at, sir?

VALE: Albert Mansions, Victoria Street.

CHARLOTTE: *(To VALE.)* Oh, thank you, I always fancied that spot.

MESSITER: Very much obliged, gentlemen.

LUKYN: *(Who has listened to VALE's answers in helpless horror.)*

By George, well out of it!

The two ladies give a cry of relief. CHARLOTTE totters across to AGATHA, who embraces her. Taking down the overcoats and throwing one to VALE.

Vale, your coat.

Enter HARRIS.

HARRIS: *(To MESSITER.)* Very sorry, sir; the two other gentlemen got clean off, through the back scullery door – old hands, to all appearance.

MESSITER stamps his foot, with an exclamation.

AGATHA: *(To herself.)* My boy – saved!

LUKYN: *(To HARRIS, who stands before the door.)* Constable, get out of the way.

MESSITER: *(Sharply.)* Harris!

HARRIS: *(Without moving.)* Yes, sir.

MESSITER: You will leave the hotel with these ladies, and not lose sight of them till you've ascertained what their names *are,* and where they *do* live.

LUKYN *and* VALE: What!

AGATHA *and* CHARLOTTE: Oh!

MESSITER: Your own fault, gentlemen; it's my duty.

LUKYN: *(Violently.)* And it is *my* duty to save these helpless women from the protecting laws of my confounded country! Vale!

VALE: *(Putting his coat on the sofa.)* Active!

LUKYN: *(To HARRIS.)* Let these ladies pass!

He takes HARRIS by the collar and flings him over to VALE, who throws him over towards the ladies, who push him away. MESSITER puts a whistle to his mouth and blows; there is an immediate answer from without.

More of your fellows outside?

MESSITER: Yes, sir, at your service. Very sorry, gentlemen, but you and your party are in my custody.

LUKYN *and* VALE: What?

AGATHA *and* CHARLOTTE: Oh!

MESSITER: For assaulting this man in the execution of his duty.

LUKYN: You'll dare to lock us up all night?

MESSITER: It's one o'clock now, Colonel – you'll come on first thing in the morning.

LUKYN: Come on? At what Court?

MESSITER: Mulberry Street.

AGATHA: *(With a scream.)* Ah! The magistrate?

MESSITER: Mr. Posket, mum.

AGATHA sinks into a chair, CHARLOTTE at her feet; LUKYN, overcome, falls on VALE's shoulders.

Curtain.

Act Three

The Magistrate's room at Mulberry Street Police Court, with a doorway covered by curtains leading directly into the Court, and a door opening into a passage. It is the morning after the events of the last Act.

POLICE SERGEANT LUGG, a middle-aged man with a slight country dialect, enters with 'The Times' newspaper, and proceeds to cut it and glance at its contents while he hums a song.

Enter MR. WORMINGTON, an elderly, trim and precise man.

WORMINGTON: Good morning, Lugg.

LUGG: Morning, Mr. Wormington.

WORMINGTON: Mr. Posket not arrived yet?

LUGG: Not yet, sir. Hullo! *(Reading.)* 'Raid on a West End Hotel. At an early hour this morning – '

WORMINGTON: Yes, I've read that – a case of assault upon the police.

LUGG: Why, these must be the folks who've been so precious rampageous all night.

WORMINGTON: Very likely.

LUGG: Yes, sir, protestin' and protestin' till they protested everybody's sleep away. Nice-looking women, too, though as I tell Mrs. Lugg, now-a-days there's no telling who's the lady and who isn't. Who's got this job, sir?

WORMINGTON: Inspector Messiter.

LUGG: *(With contempt.)* Messiter! That's luck! Why he's the worst elocutionist in the force, sir. *(As he arranges the newspaper upon the table, he catches sight of WORMINGTON's necktie, which is bright red.)* Well, I – excuse me, Mr. Wormington, but all the years I've had the honour of

knowin' you, sir, I've never seen you wear a necktie with, so to speak, a dash of colour in it.

WORMINGTON: *(Uneasily.)* Well, Lugg, no, that's true, but to-day is an exceptional occasion with me. It is, in fact, the twenty-fifth anniversary of my marriage, and I thought it due to Mrs. Wormington to vary, in some slight degree, the sombreness of my attire. I confess I am a little uneasy in case Mr. Posket should consider it at all disrespectful to the Court.

LUGG: Not he, sir.

WORMINGTON: I don't know. Mr. Posket is punctiliousness itself in dress, and his cravat's invariably black. However, it is not every man who has a silver wedding-day.

LUGG: It's not every man as wants one, sir.

WORMINGTON goes out. At the same moment POSKET enters quickly, and leans on his chair as if exhausted. His appearance is extremely wretched; he is still in evening dress, but his clothes are muddy, and his linen soiled and crumpled, while across the bridge of his nose he has a small strip of black plaster.

POSKET: *(Faintly.)* Good morning, Lugg.

LUGG: Good morning to you, sir. Regretting the liberty I'm taking, sir – I've seen you look more strong and hearty.

POSKET: I am fairly well, thank you, Lugg. My night was rather – rather disturbed. Lugg!

LUGG: Sir?

POSKET: *(Nervously.)* Have any inquiries been made about me this morning – any messenger from Mrs. Posket, for instance, to ask how I am?

LUGG: No, sir.

POSKET: Oh. My child, my stepson, young Mr. Farringdon has not called, has he?

LUGG: No, sir.

POSKET: *(To himself.)* Where can that boy be? *(To .*
Thank you, that's all.

LUGG: *(Who has been eyeing POSKET with astonishment, g*
door, and then touches the bridge of his nose. Sympatheticu

Nasty cut while shavin', sir? *(Goes out.)*

POSKET: Where can that boy have got to? If I could only
remember how, when, and where we parted! I think it was
at Kilburn. Let me think – first, the kitchen. *(Putting his
hand to his side as if severely bruised.)* Oh! Cis was all right,
because I fell underneath; I felt it was my duty to do *so*.
Then what occurred? A dark room, redolent of onions
and cabbages and paraffin oil, and Cis dragging me over
the stone floor, saying, 'We're in the scullery, Guv; let's try
and find the tradesmen's door.' Next, the night air – oh,
how refreshing! Cis, my boy, we will both learn a lesson
from to-night never deceive.' Where are we? In Argyll
Street. 'Look out, Guv, they're after us.' Then – then, as
Cis remarked when we were getting over the railings of
Portman Square – then the fun began. We over into the
Square – they after us. Over again, into Baker Street. Down
Baker Street. Curious recollections, whilst running, of my
first visit, as a happy child, to Madame Tussaud's, and
wondering whether her removal had affected my fortunes.
'Come on, Guv – you're getting blown.' Where are we?
Park Road. What am I doing? Getting up out of a puddle.
St. John's Wood. The cricket-ground. 'I say, Guv, what a
run this would be at Lord's, wouldn't it? And no fear of
being run out either, more fear of being run in.' 'What road
is this, Cis? Maida Vale. Good gracious! A pious aunt of
mine once lived in Hamilton Terrace; she never thought I
should come to this. 'Guv?' says Cis 'Yes my boy.' 'Let's get
this kind-hearted coffee stall keeper to hide us.' We apply.
'Will you assist two unfortunate gentleman?' 'No, blowed if
I will.' 'Why not?' 'Cos I'm goin' to join in the chase after
you.' Ah! Off again, along Maida Vale! On, on, heaven
knows how or where, 'till at last no sound of pursuit, no
Cis, no breath, and the early Kilburn buses starting to

town. Then I came back again, and not much too soon for the Court. *(Going up to the washstand and looking into the little mirror, with a low groan.)* Oh, how shockingly awful I look, and how stiff and sore I feel! *(Taking off his coat and hanging it on a peg, then washing his hands.)* Where's the soap? What a weak, double-faced creature to be a magistrate. I shall put five pounds and costs into the poor's box tomorrow. But I deserve a most severe caution. Ah, perhaps I shall get that from Agatha. *(He takes off his white tie, rolls it up and crams it into his pocket.)* When Wormington arrives I will borrow some money and send out for a black cravat. All my pocket money is in my overcoat at the Hôtel des Princes. If the police seize it there is some consolation in knowing that that money will never be returned to me. *(There is a knock at the door.)* Come in!

Enter LUGG.

LUGG: Your servant, Mr. Wyke, wants to see you, sir.

POSKET: *(Testily.)* Bring him in. *(LUGG goes out.)* Wyke! From Agatha! From Agatha!

Re-enter LUGG, with WYKE.

WYKE: Ahem! Good morning, sir.

POSKET: Good morning, Wyke. Ahem! Is Master Farringdon quite well?

WYKE: He hadn't arrived home when I left, sir.

POSKET: Oh! Where is that boy? *(To WYKE.)* How is your mistress this morning, Wyke?

WYKE: Very well, I hope, sir; *she* ain't come home yet, either.

POSKET: Not returned – nor Miss Verrinder?

WYKE: No, sir – neither of them.

POSKET: *(To himself.)* Lady Jenkins is worse; they are still nursing her! Good women, true women!

WYKE: *(To himself.)* That's eased his deceivin' old mind.

POSKET: *(To himself.)* Now if the servants don't betray me and Cis returns safely, the worst is over. To what a depth I have fallen when I rejoice at Lady Jenkins's indisposition!

WYKE: Cook thought you ought to know that the mistress hadn't come home, sir.

POSKET: Certainly. Take a cab at once to Campden Hill and bring me back word how poor Lady Jenkins is. Tell Mrs. Posket I will come on the moment the Court rises.

WYKE: Yes, sir.

POSKET: And Wyke. It is not at all necessary that Mrs. Posket should know of my absence with Master Farringdon from home last night. Mrs. Posket's present anxieties are more than sufficient. Inform Cook and Popham and the other servants that I shall recognise their discretion in the same spirit I have already displayed towards you.

WYKE: *(With sarcasm.)* Thank you, sir. I will. *(He produces from his waistcoat-pocket a small packet of money done up in newspaper, which he throws down upon the table.)* Meanwhile, sir, I thought you would like to count up the little present of money you gave me last night, and in case you thought you'd been over-liberal, sir, you might halve the amount. It isn't no good spoiling of us all, sir.

Enter LUGG.

POSKET: You are an excellent servant, Wyke; I am very pleased. I will see you when you return from Lady Jenkins's. Be quick.

WYKE: Yes, sir. *(To himself.)* He won't give me twopence again in a hurry. *(He goes out; LUGG is about to follow.)*

POSKET: Oh, Lugg, I want you to go to the nearest hosier's and purchase me a neat cravat.

LUGG: *(Looking inquisitively at POSKET.)* A necktie, sir?

POSKET: Yes. *(Rather irritably, turning up his coat collar to shield himself from LUGG's gaze.)* A necktie – a necktie.

LUGG: What sort of a kind of one, sir?

POSKET: Oh, one like Mr. Wormington's.

LUGG: One like he's wearing this morning, sir?

POSKET: Of course, of course, of course.

LUGG: *(To himself.)* Fancy him being jealous of Mr. Wormington, now. Very good, sir what price, sir?

POSKET: The best. *(To himself.)* There now, I've no money. *(Seeing the packet on table.)* Oh, pay for it with this, Lugg.

LUGG: Yes, sir.

POSKET: And keep the change for your trouble.

LUGG: *(Delighted.)* Thank you, sir; thank you, sir – very much obliged to you, sir. *(To himself.)* That's like a liberal gentleman. *(Goes out.)*

At the same moment WORMINGTON enters through the curtains with the charge sheet in his hand. WORMINGTON, on seeing POSKET, uneasily tucks his pocket-handkerchief in his collar so as to hide his necktie.

WORMINGTON: H'm! Good morning.

POSKET: Good morning, Wormington.

WORMINGTON: The charge sheet.

POSKET: Sit down.

WORMINGTON puts on his spectacles; POSKET also attempts to put on his spectacles, but hurts the bridge of his nose, winces, and desists.

POSKET: *(To himself.)* My nose is extremely painful. *(To WORMINGTON.)* You have a bad cold I am afraid, Wormington – bronchial?

WORMINGTON: Ahem! Well – ah – the fact is – you may have noticed how very chilly the nights are.

POSKET: *(Thoughtfully.)* Very, very.

WORMINGTON: The only way to maintain the circulation is to run as fast as one can.

POSKET: To run – as fast as one can – yes – quite so.

WORMINGTON: *(To himself, looking at POSKET's shirt front.)* How very extraordinary – he is wearing no cravat whatever!

POSKET: *(Buttoning up his coat to avoid WORMINGTON's gaze.)* Anything important this morning?

WORMINGTON: Nothing particular after the first charge, a serious business arising out of the raid on the Hôtel des Princes.

POSKET: *(Starting.)* Hôtel des Princes?

WORMINGTON: Inspector Messiter found six persons supping there at one o'clock this morning. Two contrived to escape.

POSKET: Dear me – I mean, did they?

WORMINGTON: But they left their overcoats behind them, and it is believed they will be traced.

POSKET: Oh, do you – do you think it is worth while? The police have a great deal to occupy them just now.

WORMINGTON: But surely if the police see their way to capture anybody we had better raise no obstacle.

POSKET: No – no – quite so – never struck me.

WORMINGTON: *(Referring to charge sheet.)* The remaining four it was found necessary to take into custody.

POSKET: Good gracious! What a good job the other two didn't wait! I beg your pardon – I mean – you say we have four?

WORMINGTON: Yes, on the charge of obstructing the police. The first assault occurred in the supper-room – the second in the four-wheeled cab on the way to the station. There were five persons in the cab at the time – the two women, the two men, and the Inspector.

POSKET: Dear me, it must have been a very complicated assault. Who are the unfortunate people?

WORMINGTON: The men are of some position. *(Reading.)* 'Alexander Lukyn, Colonel – '

POSKET: Lukyn! I-I-know Colonel Lukyn; we are old schoolfellows.

WORMINGTON: Very sad! *(Reading.)* The other is 'Horace, etc. etc. Vale – Captain – Shropshire Fusiliers'.

POSKET: And the ladies?

WORMINGTON: Call themselves 'Alice Emmeline Fitzgerald and Harriet Macnamara'.

POSKET: *(To himself.)* Which is the lady who was under the table with me?

WORMINGTON: They are not recognised by the police at present, but they furnish incorrect addresses, and their demeanour is generally violent and unsatisfactory.

POSKET: *(To himself.)* Who pinched me – Alice or Harriet?

WORMINGTON: I mention this case because it seems to be one calling for most stringent measures.

POSKET: Wouldn't a fine, and a severe warning from the Bench to the two persons who have got away –

WORMINGTON: I think not. Consider, Mr. Posket, not only defying the licensing laws, but obstructing the police!

POSKET: *(Reflectively.)* That's true – it is hard, when the police are doing anything, that they should be obstructed.

Enter LUGG.

LUGG: *(Attempting to conceal some annoyance.)* Your necktie, sir.

POSKET: *(Sharply.)* S-ssh!

WORMINGTON: *(To himself.)* Then he *came* without one – dear me!

LUGG: *(Clapping down a paper parcel on the table.)* As near like Mr. Wormington's as possible – brighter if anything.

POSKET: *(Opening the parcel, and finding a very common, gaudy neckerchief.)* Good gracious! What a horrible affair!

LUGG: *(Stolidly.)* According to my information, sir – like Mr. Wormington's.

POSKET: Mr. Wormington would never be seen in such an abominable colour.

WORMINGTON: *(In distress.)* Well – really – *I* – *(Removing the handkerchief from his throat.)* I am extremely sorry.

POSKET: My dear Wormington!

WORMINGTON: I happen to be wearing something similar the first time for five-and-twenty years.

POSKET: Oh, I beg your pardon. *(To himself.)* Everything seems against me.

LUGG: One-and-nine it come to, sir. *(Producing the paper ticket of money and laying it upon the table.)* And I brought back all the money you give me, thinking you'd like to look over it quietly. Really, Sir, I never showed up smaller in any shop in all my life!

POSKET: *(Out of patience.)* Upon my word. First one and then another! What *is* wrong with the money? *(Opens the packet.)* Twopence! *(To himself, aghast.)* That man Wyke will tell all to Agatha! Oh, everything is against me!

LUGG has opened the door, taken a card from someone outside and handed it to WORMINGTON.

WORMINGTON: From cell No. 3. *(Handing the card to POSKET.)*

POSKET: *(Reading.)* 'Dear Posket, for the love of goodness see me before the sitting of the Court. Alexander Lukyn: Poor dear Lukyn! What on earth shall I do?

WORMINGTON: Such a course would be most unusual.

POSKET: *(Despairingly.)* Everything is unusual. Your cravat is unusual. This prisoner is invited to dine at my house to-day – that's peculiar. He is my wife's first husband's only child's godfather – that's a little out of the ordinary.

WORMINGTON: The charge is so serious!

POSKET: But I am a man as well as a magistrate; advise me, Wormington, advise me!

WORMINGTON: Well – you can apply to yourself for permission to grant Colonel Lukyn's request.

POSKET: *(Hastily scribbling on LUKYN's card.)* I do – I do – and after much conflicting argument I consent to see Colonel Lukyn here immediately. *(Handing the card to WORMINGTON who passes it to LUGG, who then goes out.)* Don't leave me, Wormington – you must stand by me to see that I remain calm, firm, and judicial. *(He hastily puts on the red necktie in an untidy manner; it sticks out grotesquely.)* Poor Lukyn! I must sink the friend in the magistrate, and in dealing with his errors apply the scourge to myself. Wormington, tap me on the shoulder when I am inclined to be more than usually unusual.

WORMINGTON stands behind him. LUGG enters with LUKYN. LUKYN's dress clothes are much soiled and disordered, and he too has a small strip of plaster upon the bridge of his nose. There is a constrained pause; LUKYN and POSKET both cough uneasily.

LUKYN: *(To himself.)* Poor Posket!

POSKET: *(To himself.)* Poor Lukyn!

LUKYN: *(To himself.)* I suppose he has been sitting up for his wife all night, poor devil! Ahem! How are you, Posket?

WORMINGTON touches POSKET's shoulder.

POSKET: *(Pulling himself together.)* I regret to see you in this terrible position, Colonel Lukyn.

LUKYN: By George, old fellow, I regret to find myself in it. *(Sitting, and taking up newspaper.)* I suppose they've got us in *The Times,* confound 'em!

While LUKYN is reading the paper, POSKET and WORMINGTON hold a hurried consultation respecting LUKYN's behaviour.

POSKET: *(With dignity.)* Hem! Sergeant, I think Colonel Lukyn may be accommodated with a chair.

LUGG: He's in it sir.

LUKYN: *(Rising and putting down paper.)* Beg your pardon; forgot where I was. I suppose everything must be formal in this confounded place?

POSKET: I am afraid, Colonel Lukyn, it will be necessary even here to preserve strictly our unfortunate relative positions. *(LUKYN bows.)* Sit down. *(LUKYN sits again. POSKET takes up the charge sheet.)* Colonel Lukyn! In addressing you now, I am speaking, not as a man, but as an instrument of the law. As a man I may or may not be a weak, vicious, despicable creature.

LUKYN: Certainly – of course.

POSKET: But as a magistrate I am bound to say you fill me with pain and astonishment.

LUKYN: Quite right – every man to his trade; go on, Posket.

POSKET: *(Turning his chair to face LUKYN.)* Alexander Lukyn when I look at you – when I look at you – *(He attempts to put on his spectacles, but hurts his nose again. To himself.)* Ah my nose. *(To LUKYN, holding his spectacles a little way from his nose.)* I say, when I look at you, Alexander Lukyn, I confront a most mournful spectacle. A military officer, trained in the ways of discipline and smartness, now, in consequence of his own misdoings, lamentably bruised and battered, shamefully disfigured by sticking plaster, with his apparel soiled and damaged – all terrible evidence of a conflict with that power of which I am the representative.

LUKYN: *(Turning his chair to face POSKET.)* Well, Posket, if it comes to that, when I look at you, when I look at you – *(He attempts to fix his glass in his eye, and hurts his nose.)* confound my nose! *(To POSKET.)* When I look at you, *you* are not a very imposing object this morning.

POSKET: *(Uneasily.)* Lukyn!

LUKYN: You look quite as shaky as I do – and you're not quite innocent of sticking plaster.

POSKET: *(Rising.)* Lukyn! Really!

LUKYN: And as for our attire, we neither of us look as if we had slipped out of a bandbox.

POSKET: *(In agony.)* Don't, Lukyn, don't! Pray respect my legal status!

WORMINGTON leads POSKET back to his seat.

Thank you, Wormington. Alexander Lukyn, I have spoken. It remains for you to state your motive in seeking this painful interview.

LUKYN: Certainly! Hem! You know, of course, that I am not alone in this affair?

POSKET: *(Referring to charge sheet.)* Three persons appear to be charged with you.

LUKYN: Yes. Two others got away. Cowards! If ever I find them, I'll destroy them!

POSKET: *(Wiping his brow.)* Lukyn!

LUKYN: I will! Another job for you, Posket.

POSKET: *(With dignity.)* I beg your pardon; in the event of such a deplorable occurrence, I should not occupy my present position. Go on, sir.

LUKYN: Horace Vale and I are prepared to stand the brunt of our misdeeds. *(Seriously.)* But Posket, there are ladies in the case.

POSKET: In the annals of the Mulberry Street Police Court such a circumstance is not unprecedented.

LUKYN: Two helpless, forlorn ladies.

POSKET: *(Referring to charge sheet.)* Alice Emmeline Fitzgerald and Harriet Macnamara. *(Gravely shaking his head.)* Oh, Lukyn, Lukyn!

LUKYN: Pooh! I ask no favour for myself or Vale, but I come to you, Posket, to beg you to use your power to release these two ladies without a moment's delay.

WORMINGTON touches POSKET's shoulder.

POSKET: Upon my word, Lukyn! Do you think I am to be undermined?

LUKYN: *(Hotly.)* Undermine the devil, sir! Don't talk to me! Let these ladies go, I say! Don't bring them into Court, don't see their faces – don't hear their voices – if you do, you'll regret it!

POSKET: Colonel Lukyn!

LUKYN: *(Leaning across the table and gripping POSKET by the shoulder.)* Posket, do you know that one of these ladies is a married lady?

POSKET: Of course I don't sir. I blush to hear it.

LUKYN: And do you know that from the moment this married lady steps into your confounded Court, the happiness, the contentment of a doting husband become a confounded wreck and ruin?

POSKET: *(Rising.)* Then, sir, let it be my harrowing task to open the eyes of this foolish doting man to the treachery, the perfidy, which nestles upon his very hearthrug!

LUKYN: *(Sinking back.)* Oh, lor'! Be careful, Posket! By George, be careful!

POSKET: Alexander Lukyn, you are my friend. Amongst the personal property taken from you when you entered these precincts may have been found a memorandum of an engagement to dine at my house to-night at a quarter to eight o'clock. But Lukyn, I solemnly prepare you, you stand in danger of being late for dinner! I go further – I am not sure, after this morning's proceedings, that Mrs. Posket will be ready to receive you.

LUKYN: I'm confoundedly certain she *won't!*

POSKET: Therefore, Lukyn, as an English husband and father it will be my duty to teach you and your disreputable companions, *(Referring to charge-sheet.)* Alice Emmeline Fitzgerald and Harriet Macnamara, some rudimentary notions of propriety and decorum.

LUKYN: *(Rising.)* Confound you, Posket – listen!

POSKET: *(Grandly.)* I am listening, sir, to the guiding voice Mrs. Posket – that newly made wife still blushing from the embarrassment of her second marriage, and that voice says, 'Strike for the sanctity of hearth and home, for the credit of the wives of England – no mercy!'

WORMINGTON: It is time to go into Court, sir. The charge against Colonel Lukyn is first on the list.

LUKYN: Posket, I'll give you one last chance! If I write upon a scrap of paper the real names of these two unfortunate ladies, will you shut yourself up for a moment, away from observation, and read these names before you go into Court?

POSKET: Certainly not, Colonel Lukyn! I cannot be influenced by private information in dealing with an offence which is, in my opinion, as black as – as my cravat! Ahem!

WORMINGTON and POSKET look at each other's necktie and turn up their collars hastily.

LUKYN: *(To himself.)* There's no help for it. Then, Posket, you must have the plain truth where you stand, by George! The two ladies who are my companions in this affair are –

POSKET: Sergeant! Colonel Lukyn will now join his party.

LUGG steps up to LUKYN sharply.

LUKYN: *(Boiling with indignation.)* What, sir? What?

POSKET: Lukyn, I think we both have engagements – will you excuse me?

LUKYN: *(Choking.)* Posket! You've gone too far! If you went down on your knees – which you appear to have been

recently doing – and begged the names of these two ladies, you shouldn't have 'em! No sir, by George, you shouldn't.

POSKET: Good morning, Colonel Lukyn.

LUKYN: You've lectured me, pooh-poohed me, snubbed me – a soldier, sir – a soldier! But when I think of your dinner party to-night, with my empty chair – like Banquo, by George, sir – and the chief dish composed of a well-browned, well-basted, family skeleton, served up under the best silver cover, I pity you, Posket! Good morning!

He marches out with LUGG.

POSKET: Ah! Thank goodness that ordeal is passed. Now, Wormington, I think I am ready to face the duties of the day. Shall we go into Court?

WORMINGTON: Certainly, sir,

WORMINGTON gathers up papers from the table. POSKET with a shaking hand pours out water from carafe and drinks.

POSKET: *(To himself.)* My breakfast. *(To WORMINGTON.)* I hope I defended the sanctity of the Englishman's hearth, Wormington?

WORMINGTON: You did, indeed. As a married man, I thank you.

POSKET: *(Unsteadily.)* Give me your arm, Wormington. I am not very well this morning, and this interview with Colonel Lukyn has shaken me. I think your coat-collar is turned up, Wormington.

WORMINGTON: So is yours, I fancy, sir.

POSKET: Ahem!

They turn their collars down; POSKET takes WORMINGTON's arm. They are going towards the curtains when WYKE enters hurriedly at the door.

WYKE: *(Panting.)* Excuse me, sir.

WORMINGTON: Hush, hush! Mr. Posket is just going into Court.

WYKE: Lady Jenkins has sent me back to tell you that she hasn't seen the missis for the last week or more.

POSKET: Mrs. Posket went to Campden Hill with Miss Verrinder last night!

WYKE: They haven't arrived there, sir.

POSKET: Haven't arrived!

WYKE: No sir – and even a slow four-wheeler won't account for that.

POSKET: Wormington, there's something wrong! Mrs. Posket quitted a fairly happy home last night and has not been or heard of since!

WORMINGTON: *(Taking his arm again.)* Pray don't be anxious, sir, the Court is waiting.

POSKET: *(In a frenzy, shaking him off.)* But I am anxious! Tell Sergeant Lugg to look over the Accident-Book, this morning's Hospital Returns, List of Missing Children, Suspicious Pledges, People left chargeable to the Parish, Attend to your Window Fastenings – ! I – I – Wormington, Mrs. Posket and I disagreed last night!

WORMINGTON: *(Soothingly.)* Don't think of it, sir; you should hear me and Mrs. Wormington. Pray do come into Court.

POSKET: *(Hysterically.)* Court! I'll be totally unfit for business, totally unfit for business!

WORMINGTON hurries him off through the curtain.

Enter LUGG, almost breathless.

LUGG: We've got charge one in the Dock – all four of 'em. *(Seeing WYKE.)* Hallo, you back again!

WYKE: Yes – seems so. *(They stand facing each other, dabbing their foreheads with their handkerchiefs.)* Phew! You seem warm.

LUGG: Phew! You don't seem so cool.

WYKE: I've been lookin' after two ladies.

LUGG: So have I.

WYKE: I haven't found 'em.

LUGG: If I'd known, I'd 'a been pleased to lend you our two.

From the other side of the curtains there is the sound of a shriek from AGATHA and CHARLOTTE.

WYKE: Lor', what's that!

LUGG: That *is* our two. Don't notice them – they're hystericals. They're mild now to what they have been. I say, old fellow is your Guv'nor all right in his head?

WYKE: I suppose so – why?

LUGG: I've a partickler reason for asking. Does he ever tell you to buy him anything and keep the change?

WYKE: What d'yer mean?

LUGG: Do you ever get any tips?

WYKE: Rather. What do you think he made me a present of last night?

LUGG: Don't know.

WYKE: Twopence – to buy a new umbrella.

LUGG: Well, I'm blessed! And he gave me the same sum to get him a silk necktie. It's my opinion he's got a softenin' of the brain. *(Another shriek from the two women, a cry from POSKET, and then a hubbub are heard. Running up to the curtains and looking through.)* Hallo, what's wrong? Here! I told you so – he's broken out, he's broken out.

WYKE: Who's broken out?

LUGG: The lunatic. Keep back, I'm wanted. *(He goes through the curtains.)*

WYKE: *(Looking after him.)* Look at the Guv'nor waving his arms and going on anyhow at the prisoners! Prisoners! Gracious goodness – it's the missis!

Amid a confused sound of voices POSKET is brought in through the curtains by WORMINGTON. LUGG follows. POSKET is placed in a chair. WORMINGTON holds a glass of water to his lips.

POSKET: *(Wildly.)* Wormington, Wormington! The two ladies, the two ladies! I know them!

WORMINGTON: *(Soothingly.)* It's all right, sir, it's all right don't be upset, sir!

POSKET: I'm not well; what shall I do?

WORMINGTON: Nothing further, sir. What you have done is quite in form.

POSKET: What I *have* done?

WORMINGTON: Yes, sir – you did precisely what I suggested – took the words from me. They pleaded guilty.

POSKET: Guilty!

WORMINGTON: Yes, sir – and you sentenced them.

POSKET: *(Starting up.)* Sentenced them! The ladies!

WORMINGTON: Yes, sir. You've given them seven days, without the option of a fine.

POSKET collapses into WORMINGTON's arms.

SCENE II

POSKET's drawing-room, as in the first act.

Enter BEATIE timidly, dressed in simple walking-costume.

BEATIE: How dreadfully early! Eleven o'clock, and I'm not supposed to come till four. I wonder why I want to instruct Cis all day. I'm not nearly so enthusiastic about the two little girls I teach in Russell Square.

Enter POPHAM. Her eyes are red as if from crying.

POPHAM: *(Drawing back on seeing BEATIE.)* That music person again. I beg your pardon – I ain't got no instructions to prepare no drawing-room for no lessons till four o'clock.

BEATIE: *(Haughtily.)* I wish to see Mrs. Posket.

POPHAM: She hasn't come home.

BEATIE: Oh, then – er – um – Master Farringdon will do.

POPHAM: *(In tears.)* He haven't come home either!

BEATIE: Oh, where is he?

POPHAM: No one knows! His wicked old stepfather took him out late last night and hasn't returned him. Such a night as it was, too, and him still wearing his summer under-vests.

BEATIE: Mr. Posket?

POPHAM: Mr. Posket – no, my Cis!

BEATIE: How dare you speak of Master Farringdon in that familiar way?

POPHAM: How dare I? Because me and him formed an attachment before ever you darkened our doors. *(Taking a folded printed paper from her pocket.)* You may put down the iron 'eel too heavy, Miss Tomlinson. I refer you to *Bow Bells'* First Love is Best Love; or, The Fingerless Pianist.' *(Offers paper.)*

Enter CIS, looking very pale, worn out, and dishevelled.

POPHAM *and* BEATIE: Oh!

CIS: *(Staggering to a chair.)* Where's the mater?

POPHAM: Not home yet.

CIS: *(Faintly.)* Thank giminy!

BEATIE: He's ill!

POPHAM: Oh!

BEATIE, assisted by POPHAM, quickly wheels the large armchair forward. They catch hold of CIS and place him in it; he submits limply.

BEATIE: *(Taking CIS's hand.)* What is the matter, Cis dear? Tell Beatie.

POPHAM: *(Taking his other hand, indignantly.)* Well, I'm sure! Who's given you raisins and ketchup from the store cupboard? Come back to Emma!

CIS, with his eyes closed, gives a murmur.

BEATIE: He's whispering!

They both bob their heads down to listen.

POPHAM: He says his head's a-whirling.

BEATIE: Put his legs up.

They take off his boots, loosen his necktie, and dab his forehead with water out of a flower-vase.

CIS: *(Indistinctly.)* I – I – I wish you two girls would leave off.

They bob their heads down as before.

BEATIE: He's speaking again. He hasn't had any breakfast! He's hungry!

POPHAM: Hungry! I thought he looked thin. Wait a minute, dear. Emma Popham knows what her boy fancies!

She runs out of the room.

CIS: Oh, Beatie, hold my head while I ask you something.

BEATIE: Yes, darling?

CIS: No lady would marry a gentleman who had been a convict, would she?

BEATIE: No; certainly not!

CIS: I thought not. Well, Beatie, I've been run after by a policeman.

BEATIE: *(Leaving him.)* Oh!

CIS: *(Rising unsteadily.)* Not caught, you know, only run and walking home from Hendon this morning I came to the conclusion that I ought to settle down in life. Beatie – could I write out a paper promising to marry you when I'm one and twenty?

BEATIE: Don't be a silly boy – of course you could.

CIS: Then I shall; and when I feel inclined to have a spree I shall think of that paper and say, 'Cis Farringdon, if you ever get locked up, you'll lose the most beautiful girl in the world.'

BEATIE: And so you will.

CIS: I'd better write it now, before my head gets well again.

He writes; she bends over him.

BEATIE: *(Tenderly.)* You simple, foolish Cis! If your head is so queer, shall I tell you what to say?

Enter POPHAM, carrying a tray with breakfast dishes.

POPHAM: *(To herself.)* He won't think so much of *her* now. His breakfast is my triumph. *(To CIS.)* Coffee, bacon, and a teacake.

BEATIE: Hush! Master Farringdon is writing something very important.

POPHAM: *(Going to the window.)* That's a cab at our door.

CIS: It must be the mater – I'm off!

He picks up his boots and goes out quickly.

BEATIE: *(Following him with the paper and inkstand.)* Cis, Cis! You haven't finished the promise! You haven't finished the promise!

LUGG: *(Outside.)* All right, sir – I've got you – I've got you.

POPHAM opens the door.

POPHAM: The master and a policeman!

Enter LUGG, supporting POSKET, who sinks into an armchair with a groan.

Oh, what's the matter?

LUGG: All right, my good girl, you run downstairs and fetch a drop of brandy and water. *(POPHAM hurries out.)*

POSKET: *(Groaning again.)* Oh!

LUGG: Now don't take on *so,* sir. It's what might happen to any married gentleman. Now, you're all right now, sir. And I'll hurry back to the Court to see whether they've sent for Mr. Bullamy.

POSKET: My wife! My wife!

LUGG: *(Soothingly.)* Oh, come now, sir, what *is* seven days! Why, many a married gentleman in your position, sir, would have been glad to have made it fourteen.

POSKET: Go away – leave me.

LUGG: Certainly sir.

Re-enter POPHAM with a small tumbler of brandy and water; he takes it from her and drinks it.

It's not wanted. I'm thankful to say he's better.

POPHAM: *(To LUGG.)* If you please, Cook presents her compliments, and she would be glad of the pleasure of your company downstairs, before leavin'. *(They go out.)*

POSKET: Agatha and Lukyn! Agatha and Lukyn supping together at the Hôtel des Princes, while I was at home and asleep – while I ought to have been at home and asleep! It's awful!

CIS: *(Looking in at the door.)* Hallo, Guv!

POSKET: *(Starting up.)* Cis!

Enter CIS.

CIS: Where did you fetch, Guv?

POSKET: Where did I fetch! You wretched boy! I fetched Kilburn, and I'll fetch you a sound whipping when I recover my composure.

CIS: What for?

POSKET: For leading me astray, sir. Yours is the first bad companionship I have ever formed! Evil communication

with you, sir, has corrupted me! *(Taking CIS by the collar shaking him.)* Why did you abandon me at Kilburn?

CIS: Because you were quite done, and I branched off to draw the crowd away from you after me.

POSKET: Did you, Cis, did you? *(Putting his hand on CIS's shoulder.)* My boy – my boy! Oh Cis, we're in such trouble!

CIS: You weren't caught, Guv?

POSKET: No – but do you know who the ladies are who were supping at the Hôtel des Princes?

CIS: No – do you?

POSKET: Do I? They were your mother and Aunt Charlotte.

CIS: The mater and Aunt Charlotte! Ha, ha, ha! *(Laughing and dancing with delight.)* Ha, ha! Oh, I say, Guv, what a lark!

POSKET: A lark! They were taken to the police station!

CIS: *(Changing his tone.)* My mother?

POSKET: They were brought before the magistrate and sentenced.

CIS: Sentenced?

POSKET: To seven days' imprisonment.

CIS: Oh! *(He puts his hat on fiercely.)*

POSKET: *(Alarmed.)* What are you going to do?

CIS: Get my mother out first, and then break every bone in that magistrate's body.

POSKET: Cis, Cis! He's an unhappy wretch and he did his duty.

CIS: His duty! To send another magistrate's wife to prison! Guv, I'm only a boy, but I know what professional etiquette is. Come along! Which is the police station?

POSKET: *(In agony.)* Mulberry Street.

CIS: *(Recoiling.)* Who's the magistrate?

POSKET: I am!

CIS: You! *(Seizing POSKET by the collar and shaking him.)* You dare to lock up my mother! Come with me and get her out!

He is dragging POSKET towards the door, when BULLAMY enters breathlessly.

BULLAMY: My dear Posket!

CIS: *(Seizing BULLAMY and dragging him with POSKET to the door.)* Come with me and get my mother out!

BULLAMY: Leave me alone, sir! She *is* out! *(Panting.)* I managed it.

CIS *and* POSKET: *(Together.)* How?

BULLAMY: Wormington sent to me when you were taken ill. When I arrived at the Court, he had discovered from your man-servant Mrs. Posket's awful position.

CIS: *(Warmly.)* You leave my mother alone! Go on!

BULLAMY: Said I to myself, 'This won't do; I must extricate these people somehow!' I'm not so damned conscientious as you are, Posket.

CIS: Bravo! Go on!

BULLAMY: *(Producing his jujube box.)* The first thing I did was to take a jujube.

CIS: *(Snatching the jujube box from him.)* Will you make haste?

BULLAMY: Then said I to Wormington, 'Posket was *non compos mentis* when he heard this case – I'm going to reopen the matter!'

CIS: Hurrah!

BULLAMY: And I did. And what do you think I found out from the proprietor of the hotel?

POSKET *and* CIS: What?

BULLAMY: That Mr. Cecil Farringdon here, hires a room at the Hôtel des Princes.

CIS: I know that.

BULLAMY: And that Mr. Farringdon was there last night with some low stockbroker of the name of Skinner.

CIS: Go on – go on! *(Offering him the jujube box.)* Take a jujube.

BULLAMY: *(Taking a jujube.)* Now the law, which seems to me quite perfect, allows a gentleman who rents a little apartment at an inn to eat and drink with his friends all night long.

CIS: Well?

BULLAMY: So said I from the bench, 'These ladies and gentlemen appear to be friends or relatives of a certain lodger in the Hôtel des Princes.'

CIS: So they are!

BULLAMY: 'They were all discovered in one room.'

POSKET: So we were – I mean, so they were!

BULLAMY: 'And I shall adjourn the case for a week to give Mr. Farringdon an opportunity of claiming these people his guests.'

CIS: Three cheers for Bullamy!

BULLAMY: So I censured the police for their interference and released the ladies on their own recognisances.

POSKET: *(Taking BULLAMY's hand.)* And the men?

BULLAMY: Well, unfortunately, Wormington took upon himself to despatch the men to the House of Correction before I arrived.

POSKET: *(Violently.)* I'm glad of it! They are dissolute villains! I'm glad of it.

Enter POPHAM, scared.

POPHAM: Oh, sir! Here's the missis and Miss Verrinder! In such a plight!

CIS: The mater! Guv, you explain!

He hurries out. POSKET rapidly retires into the window recess.

Enter AGATHA and CHARLOTTE, pale, red-eyed, and agitated. They carry their hats, or bonnets, which are much crushed. POPHAM goes out.

AGATHA *and* CHARLOTTE: *(Falling on to BULLAMY's shoulders.)* O-o-h-h!

BULLAMY: My dear ladies! *(They seize BULLAMY's hands.)*

AGATHA: Preserver!

CHARLOTTE: Friend!

AGATHA: How is my boy?

BULLAMY: Never better.

AGATHA: *(Fiercely.)* And the man who condemned his wife and sister-in-law to the miseries of a jail?

BULLAMY: Ahem! Posket – oh – he –

AGATHA: Is he well enough to be told what that wife thinks of him?

BULLAMY: It might cause a relapse.

AGATHA: It is my duty to risk that.

CHARLOTTE: *(Raising the covers of the dishes on the table. With an hysterical cry.)* Food!

AGATHA: Ah!

AGATHA and CHARLOTTE begin to devour a teacake voraciously.

POSKET: *(Advancing with an attempt at dignity.)* Agatha Posket!

AGATHA: *(Rising, with her mouth full and a piece of teacake in her hand.)* Sir!

CHARLOTTE takes the tray and everything on it from the table and goes towards the door.

BULLAMY: *(Stepping back.)* There's going to be an explanation.

CHARLOTTE: *(At the door.)* There's going to be an explanation.

POSKET: How dare you look me in the face, madam?

AGATHA: How dare you look at anybody in any position, sir? You send your wife to prison for pushing a mere policeman.

POSKET: I didn't know what I was doing.

AGATHA: Not when you requested two ladies to raise their veils and show their faces in the dock? We shouldn't have been discovered but for that.

POSKET: It was my duty.

AGATHA: Duty! You don't go to the Police Court again alone! I guess now, Aeneas Posket, why you clung to a single life so long. *You liked it!*

POSKET: I wish I had.

AGATHA: Why didn't you marry till you were fifty?

POSKET: Perhaps I hadn't met a widow, madam.

AGATHA: Paltry excuse. You revelled in a dissolute bachelorhood!

POSKET: Hah! Whist every evening!

AGATHA: You can't play whist *alone.* You're an expert hiding, too!

POSKET: If I were I should thrash your boy!

AGATHA: When you wished to conceal yourself last night, selected a table with a lady under it.

POSKET: *(Rubbing his arm.)* Ah, did you pinch me, or Charlotte?

AGATHA: I did – Charlotte's a single girl.

POSKET: I fancy, madam, you found my conduct under that table perfectly respectful?

AGATHA: I don't know – I was too agitated to notice.

POSKET: Evasion – you're like all the women.

AGATHA: Profligate! You oughtn't to know that.

POSKET: No wife of mine sups unknown to me, with dissolute military men; we will have a judicial separation, Mrs. Posket.

AGATHA: Certainly – I suppose you'll manage that at your police Court, too?

POSKET: I shall send for my solicitor at once.

AGATHA: Aeneas! Mr. Posket! Whatever happens, you shall not have the custody of my boy.

POSKET: Your boy! I take charge of *him?* Agatha Posket, he has been my evil genius! He has made me a gambler at an atrocious game called 'Fireworks' – he has tortured my mind with abstruse speculations concerning 'Sillikin' and 'Butterscotch' for the St. Leger – he has caused me to cower before servants, and to fly before the police.

AGATHA: He! My Cis?

Enter CIS, having changed his clothes.

CIS: *(Breezily.)* Hallo, mater – got back?

AGATHA: You wicked boy! You dare to have apartments at the Hôtel des Princes!

POSKET: Yes – and it was to put a stop to that which induced me to go to Meek Street last night.

AGATHA: A child! A mere infant! Cavorting amongst – Oysters and Burgundy and who knows what other vices –

BULLAMY: *(Suddenly realising.)* Oh Lord!

AGATHA: How could you, Cis? How could you behave in such a way?

BULLAMY: What have I done?

CIS: Don't be angry mater! Those rooms of mine have got you quite out of your difficulties.

BULLAMY: Not quite I'm afraid. Not at all, in fact – oh heaven!

POSKET: What is it Bullamy?

BULLAMY: Forgive me, Posket. Forgive me.

POSKET: What are you saying?

BULLAMY: I thought my outstretched hand was lifting you clear of grief – not condemning you to a deeper abyss.

POSKET: For heaven's sake man, make sense.

BULLAMY: The law allows for a gentleman with his own rooms to entertain guests after hours – *a Gentleman*. But a *Boy* – ?

POSKET: Merciful heaven.

BULLAMY: The child's natural sophistication made me forget the tenderness of his years – I've often remarked on it before. He is so very advanced for his age!

AGATHA: Oh Lord –

BULLAMY: And now I have adjourned the case to await his testimony.

CIS: But I will testify! Of course I will!

BULLAMY: What? To the authorship of a Saturnalia? And you – a child. How will that play in the dock, do you suppose – For you and for your unfortunate guardians?

AGATHA: This is beyond bearing.

BULLAMY: It is a public scandal!

POSKET: Enough, Bullamy. I know what I must do.

CIS: Steady on, Gov. Don't do anything rash –

POSKET: My mind is made up.

AGATHA: Posket, please –

POSKET: 'Sons should bury Fathers' isn't that the legend? I am taking full responsibility for this escapade. I am falling on my sword.

AGATHA: Posket – no – !

BULLAMY: But you'll be ruined –

POSKET: I was the adult. I was the responsible party.

AGATHA: Posket, stop – I beg you –

POSKET: I shall bear both the penalty and the shame.

AGATHA: Listen –

POSKET: Let me go.

BULLAMY: But you'll be confined, sir.

POSKET: I will. And, believe me, after the entertainments of the past twenty four hours, a small, quiet cell in Newgate will be like the garden of Gethsemane.

AGATHA: Posket, stop. I must speak – Aeneas, listen. Listen to me.

I see now that this – all this – is the result of a lack of candour on my part. Tell me – Oh, the agony of the truth! Tell me – have you ever particularly observed this child?

POSKET: *(Weakly.)* Oh!

AGATHA: Has it ever struck you he is a little forward?

POSKET: Sometimes.

AGATHA: You are wrong; he is awfully backward. *(Taking POSKET's hand.)* Aeneas, men always think they are marrying angels, and women would be angels if they never had to grow old. That warps their dispositions. I have deceived you, Aeneas.

POSKET: *(Clenching his fists.)* Ah! Lukyn!

AGATHA: No – no – you don't understand! Lukyn was my boy's godfather in 1866.

POSKET: *(Starting.)* 1866?

CIS: 1866?

CIS *and* POSKET: *(Reckoning rapidly upon their fingers.)* 1866.

AGATHA: *(Quickly.)* S-s-s-h! Don't count! Cis, go away! *(To POSKET.)* When you proposed to me in the Pantheon at Spa, you particularly remarked, 'Mrs. Farringdon, I love you for yourself *alone'*.

POSKET: I know I did.

AGATHA: Those were terrible words to address to a widow with a son of nineteen. *(CIS and POSKET again reckon rapidly upon their fingers.)* Don't count, Aeneas, don't count! Those words tempted me. I glanced at my face in a neighbouring mirror, and I said Aeneas is fifty – why should I – a mere woman, compete with him on the question of age? He has already the advantage – I will be generous – I will add to it!' I led you to believe I had been married only fifteen years ago; I deceived you and my boy as to his real age, and I told you I was but one-and-thirty.

POSKET: It wasn't the truth?

AGATHA: Ah! I merely lacked woman's commonest fault, exaggeration.

POSKET: But – Lukyn?

AGATHA: Knows the real facts. I went to him last night to beg him not to disturb an arrangement which had brought happiness to all parties. Look. In place of a wayward, troublesome child, I now present you with a youth old enough to be a joy, comfort and support!

CIS: Oh, I say, mater, this is a frightful sell for a fellow.

AGATHA: Go to your room, sir.

CIS: I always thought there was something wrong with me. Blessed if I'm not behind the age! *(CIS goes out.)*

AGATHA: Forgive me, Aeneas. Look at my bonnet! A night in Mulberry Street, without even a powder-puff, is an awful expiation.

POSKET: Agatha! How do I know Cis won't be five-and-twenty tomorrow?

AGATHA: No – no – you know the worst, and as long as I live, I'll never deceive you again – except in little things.

Enter LUKYN and VALE.

LUKYN: *(Boiling with rage.)* By George, Posket!

POSKET: My dear Lukyn!

LUKYN: Do you know I am a confounded jail-bird, sir?

POSKET: An accident!

LUKYN: And do you know what has happened to me in jail a soldier, sir – an officer?

POSKET: No.

LUKYN: I have been washed by the authorities!

POSKET: Lukyn, no!

Enter CHARLOTTE; she rushes across to VALE.

CHARLOTTE: Horace! Horace! Not you, too?

VALE: By Jove, Charlotte, I would have died first.

Enter LUGG, quickly.

LUGG: Good news Mr. Posket! Wonderful news! The scoundrel who absconded from the Hôtel des Princes last night has, at last been traced!

POSKET: I have? I mean – He has?

AGATHA: Mr. Skinner, Sir. The Stockbroker! The final piece of the puzzle!

POSKET: What?

AGATHA: Found wandering in the vicinity of the Burlington Arcade. A little the worse for wear, sir and with no memory of the previous night – but a frequent visitor to the Hôtel des Princes, that much he knew – and a stockbroker, sir, he was certain of that. And by the name of Skinner, too.

POSKET: Oh mercy! What became of the poor wretch?

LUGG: Locked away, sir. Where he was found. And awaiting the arrival of the Magistrate.

POSKET: Release him, Lugg. Release him at once.

LUGG: Sir?

POSKET: The man is innocent. All parties in that affair are quite, quite innocent.

BULLAMY: *(Drawing him aside.)* Allow me to explain, sergeant –

POSKET: *(Drawing AGATHA aside.)* Agatha, what have I done? Scarcely twenty-four hours ago I was a Magistrate, a pillar of the community. And now an entirely blameless man has spent a night in the cells on account of my caprice.

AGATHA: Nonsense. There is rarely such a thing as an entirely blameless man.

POSKET: Sergeant, what kind of a man was he, this Skinner? Was he a gentleman?

AGATHA: He was a stockbroker, sir. Connected with one of the larger Merchant trading banks in the City.

POSKET: Oh well. I expect he was guilty of something. *(Turns to AGATHA.)* What a wise, dear creature you are, Agatha. *(He kisses her.)*

AGATHA: The sudden arrival of honesty into our marriage appears to have had an unexpected effect, Aeneas.

Enter CIS, pulling BEATIE after him.

CIS: Come on, Beatie! Guv – mater! Here's news! Beatie and I have made up our minds to be married.

AGATHA: Oh!

Enter POPHAM, with champagne and glasses.

POSKET: What's this?

CIS: Bollinger – '74 – extra dry – to drink our health and happiness.

CHARLOTTE: Champagne! It may save my life!

99

AGATHA: Miss Tomlinson, go home!

POSKET: *(Grimly.)* Stop! Cis Farringdon, my dear boy, you are but nineteen at present, but you were only fourteen yesterday, so you are a growing lad; on the day you marry and start for Canada, I will give you a thousand pounds!

POPHAM: *(Putting her apron to her eyes.)* Oh!

CIS: *(Embracing BEATIE.)* Hurrah! We'll be married directly.

POSKET: Never was it truer said, by Jove. The boy is father to the man.

AGATHA: But my Cis! My little child!

POSKET: Dignity, Agatha. Dignity and sacrifice. After all he is now a grown adult.

CIS: I am, Gov! By Gimminy, Sir, I am!

POSKET: *(Tenderly kissing her cheek.)* Try to be brave. After all, a grown-up man of nineteen has no place at his mother's side, now does, he?

AGATHA turns and sees CIS and BEATIE in each other's arms and looking quite grown-up.

AGATHA: You are right, of course, my dear. *(Turning to CIS.)* And perhaps a grown-up son is easier for a woman to bear – when he lives in another continent.

POSKET: Quite so. And particularly when the woman in question has never looked her age.

AGATHA: Oh, Aeneas –

POSKET: My dearest one –

AGATHA sinks into POSKETT's arms as the curtain falls.

The End.

OTHER ARTHUR W PINERO TITLES

DANDY DICK
Adapted by Chris Luscombe
9781849434232

THE CABINET MINISTER
9781870259088

THE SECOND MRS TANQUERAY
9781849433921

WWW.OBERONBOOKS.COM

 Follow us on www.twitter.com/@oberonbooks
& www.facebook.com/oberonbook